THROUGH
BLACK EYES

ALSO BY ELTON C. FAX

GARVEY: THE STORY OF A PIONEER BLACK NATIONALIST

CONTEMPORARY BLACK LEADERS

SEVENTEEN BLACK ARTISTS

THROUGH
BLACK EYES

JOURNEYS OF A BLACK ARTIST TO
EAST AFRICA AND RUSSIA

ELTON C. FAX

Illustrated with drawings by the author

DODD, MEAD & COMPANY · NEW YORK

ISBN: 0-396-06842-1
Library of Congress Catalog Card Number: 73-9270
Printed in the United States of America

For Jim and Esther Jackson

PREFACE

HAVING spent all my life in urban slums of America's eastern sea-board cities, except for a year in rural South Carolina, I felt I needed a change of scene. So at age forty-five I went to Mexico. There I stayed for two and a half years before returning to America. During my residence in that center, through a fortunate and quite unexpected combination of circumstances, I had begun, at middle age, to see more of the world. First there was Central and South America and a portion of the Caribbean, followed by Europe and Africa. In each place I noticed something common to the existence of the ordinary folk at large.

What I noticed about them was a picturesqueness that both excited and disturbed me. Now there is a paradox in the ambivalence any artist feels toward the picturesque. After all, that is the stuff of which his dreams are made and from which his creations evolve. Yet one soon learns, from his own slum existence and from what he observed among poor relations of the rural South, that within the picturesque there often lurk foul truths no serious artist or writer can ignore.

With few exceptions I noted that wherever I saw a preponderance of "colorful natives," I found them scrambling for the meanest kind of existence in a morass of ignorance, disease, superstition, religious fervor, and miserable deprivation. At the same time, and always close at

hand, I also found cliques of sophisticated rulers or leaders of those de-graded masses. And even in instances where the former appeared to be equally as exotic as those they ruled, a distinct difference separated them. The rulers lived well.

Never did I see the ruling cliques wallowing and languishing in the misery that was smothering their subjects. Indeed, it was quite clear to me that from their positions of advantage and comfort those on top never ceased to direct their energies at preserving the gulf separating them from the have-nots, whose sweat and blood provided their luxuries. In subsequent journeys both at home and abroad I have found deviations from that general pattern to be rare indeed.

So, in this book, written and drawn from firsthand contact with two picturesque regions of the world, I choose to deal with many of those familiar patterns. I also deal with a few of the notably refreshing exceptions to them. And although it may, at surface glance, appear to be merely a pleasant, pictorial flight from the mundane norm, these pages seek to provide more as they refer from time to time to certain basic and significant historic truths.

My emphasis, for instance, upon European colonialist exploitation in both places by no means negates or ignores the fact of precolonial mistreatment of the subject peoples. Powerful and ruthless Africans and Central Asians misused their own people even before exploitation arrived from abroad. And none knows better than the misused how kicks and cuffs administered by family members hurt just as much as do those dealt by strangers. So the ugly facts of how brother has figuratively sold brother into slavery for his own gain are neither unknown nor forgotten here, as this narrative will show. But my main thrust is upon nineteenth- and twentieth-century colonialist expansion, for it is that exploitation that bears so heavily upon what I saw, heard, and felt in my wanderings.

As a black American I am especially sensitive to human exploitation. Therefore, as I traveled in East Africa and Soviet Central Asia, it

was only natural that I would relate my own experience to that of the peoples of both those areas. Since that is so, I believe I was able in a few instances to bridge chasms that have for too long divided us.

I do not in this regard immodestly suggest that I am unique. Surely there are others among us in America who view the peoples of the world as humans to be met and dealt with on terms of human equality. But our numbers must grow. And they must grow quickly if this nation of ours has any hope of occupying a place of respect among the nations of the world.

The often quoted "Oh, East is East, and West is West, and never the twain shall meet," has been promoted by those who have found it advantageous to try to create reality of it. But the cliché is now meeting the challenge its very use and misuse have inspired.

Time is a ruthless judge of men and their affairs. And time is never on the side of those reluctant to learn and fearful of change, for learning is vital to growth, and growth, like change, is vital to life itself. One is appalled to discover how many "outsiders" know more about us than we know about them. Such a situation is not good for America.

So rather than complain negatively, I take this means of doing what I can do most effectively, in the hope that my effort will help balance that deficit. In summarizing what existed in the past in East Africa and in what is now Soviet Central Asia, I have relied heavily upon the written word. In describing those aspects of the past that still exist along with newer innovations, I have used words as well as drawings.

Pictures, especially pictures of human beings, can be powerful documents. A people may *tell* you anything they choose about themselves, or they may remain mute. But nothing speaks more clearly and honestly about them and their condition than that which they show in their immediate surroundings, their body postures, and most of all *in their faces.*

Perhaps somewhere in the words and drawings there lives a spark

that will kindle the fires of imaginative investigation. Hopefully that burning curiosity will drive some to seek further understanding of the humanity of our neighbors, with whom we must share a world rendered smaller by space travel and instant communication. I earnestly hope so.

CONTENTS

	Preface	vii
	Prologue	1
1.	Uganda	9
2.	The Northern Sudan	35
3.	Ethiopia	57
4.	Tanzania	87
5.	Invitation from Moscow	105
6.	I "Discover" Uzbekistan	125
7.	Tashkent	141
8.	Samarkand	157
9.	Bukhara	169
10.	Ferghana	183
	Epilogue	194
	Index	199

THROUGH
BLACK EYES

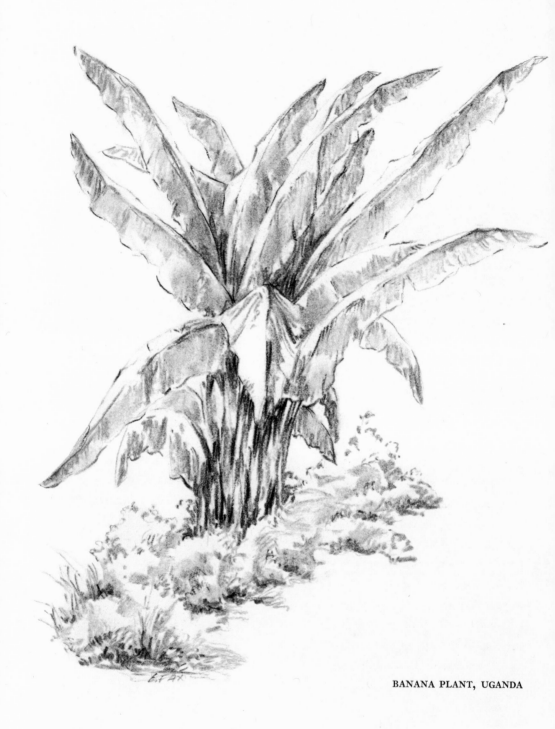

BANANA PLANT, UGANDA

PROLOGUE

EAST AFRICA and Soviet Central Asia. At first thought they seem
totally unrelated. Exotic East Africa, with her misty mountains, lush
green savannas, and humid lowlands, cradles Lake Victoria, source of
the mighty Nile. The vast plains of her national parks are the safe
roaming grounds of colorful wildlife. East Africa is where one locates
that pair of lovely ladies, Kenya and Uganda. And Kilimanjaro rises
regally from the foothills of a federation called Tanzania.

Directly across Uganda's northern border one picks up and follows
the waters of the White Nile to historic Islamic Khartoum and Om-
durman in the northern Sudan. East of those legendary twin cities the
eroding mountains of upper Ethiopia recall the chilling specter of the
region's Shifta. They are the fierce bandits whose imminence tortures
the minds of defenseless mountain travelers. How ironic that in the
manner of biblical parable, highland thugs would waylay their vic-
tims in a land where, as early as the fourth century, the Christian
Coptic Church was established. But ironies are a part of life's pattern
in East Africa, as elsewhere.

Finally one focuses upon those less notorious masses of human
souls who inhabit most regions of this earth. In East Africa they form
numerous cultural and language groups. And the majority of them are
black.

I

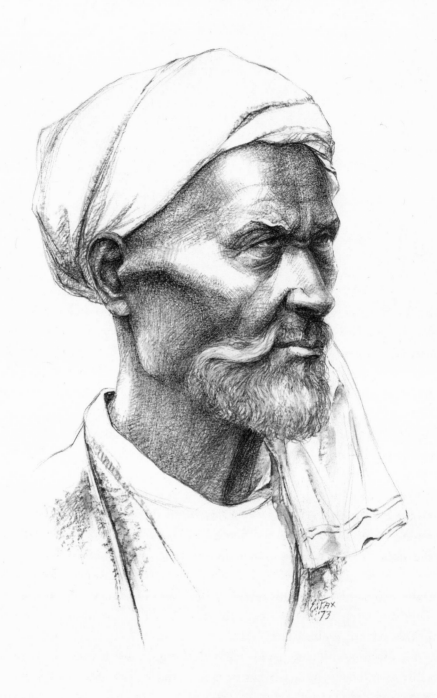

MAN OF UZBEKISTAN

Soviet Central Asia, four thousand air miles northeast, unlike the land of Africa, is everything but lush and seductive. Indeed, it is a land of treeless steppes, deserts, and rugged mountains. The Soviet Republic of Uzbekistan, my specific center of interest in Central Asia, is termed by many historians "one of the world's oldest civilized territories." Taking its modern name from Uzbek, an early fourteenth-century chief of the Golden Horde, Uzbekistan has ridden out many storms.

Its people, originally known as Sarts, have survived not only the medieval barbaric onslaughts of Genghis Khan, but the oppression of their Muslim emirates as well. In more recent times they have withstood the tyranny of Russian Czars. Today they are a productive and valuable part of the Union of Soviet Socialist Republics. Modern Uzbeks are a swarthy, Turkic people, many of them bearing strong Mongoloid physical traits. Islam is their traditional religion, and their language and culture resemble those of neighboring Iran.

Just what do East Africans and Uzbeks share in common? In the early days of their existence they experienced, as did their European counterparts, the rise and fall of empires, as well as various forms of feudal rule. Then came European colonialism. From the middle of the fifteenth century, when Portugal began her explorations along the African coast, anxious European eyes focused upon Africa's vast natural wealth. For the next four hundred years, however, only Britain and France actively joined Portugal in doing anything about it. But a cruel and greedy Belgian was to change all that. He was Leopold II, who lived between 1835 and 1909.

In September of his forty-first year Leopold assembled Germany, Austria-Hungary, Italy, and Russia to join Belgium, England, and France in a three-day unofficial planning session. Their objective was to determine how best they could open Africa to trade, from which they would be the chief beneficiaries. That meeting was but a dress rehearsal for the official Berlin Conference held eight years later, in

1884. There the non-African partitioners of Africa were joined by the Scandinavian countries, Holland, Spain, Turkey, and the United States in selecting those portions of the "Dark Continent" that each would "develop"—and exploit. Uganda and the Sudan went to Britain while Germany took Tanganyika. Of the actual formation of those colonies I shall have more to say.

At about the very time East Africa was being colonized, Central Asia, then called Turkestan, was being ogled by Czarist Russia. The territory of Uzbekistan was a particular target. Between 1867 and 1868 both Tashkent and Bukhara, celebrated khanates of Uzbekistan, fell into Russian hands. Eight years later Khiva, another Uzbek khanate, joined the first two, and Uzbekistan was a colony of the czar.

Some details of that take-over which I shall relate show that there wasn't really that much difference between greedy Asian khans and greedy Russian czars. Besides, they clearly reveal how it was possible for small European nations to seize territories in Africa and Asia, and from those acquisitions enrich their own lands while strengthening their national power. It requires little imagination to reason that those whose colonial labor has made such success of an outside power possible could hardly be expected to enjoy their limited and subservient status.

Moreover, the colonial experiences of Africa and Asia should by no means be too remote for history-conscious Americans to grasp and feel. Less than two centuries ago we also were a group of thirteen struggling and squabbling colonies, wholly dependent upon the whim of the mother country. That fact alone creates a historic link between us and our East African and Central Asian neighbors in a world diminished in size by jet air travel.

I observed yet another link uniting large segments of the peoples of East Africa to practically all Uzbeks. It was the religion of Islam. I found that faith dominant in the northern Sudan, as it is all over

Uzbekistan and I was particularly interested in how religious customs influence the present-day status of the women of both places. That was especially important to me inasmuch as women in Muslim countries have in the past been subjected to the indignities of discrimination at the hands of men who have held them to be inferior. The compulsory veil worn in public by women symbolized not only that male belief but also the sorry existence Muslim women have been forced to endure. To what extent such traditional customs still persist was something I felt compelled to investigate and if possible, determine.

Finally, it is important that I make clear exactly what I was doing in East Africa and in Soviet Central Asia. Briefly and simply, I had been invited to visit both places. I did not seek the invitations. I couldn't have, for I was not aware that either possibility existed for me. But after a number of years of working with audiences, one's name and reputation circulate, and unexpected things begin to come. I shall reveal momentarily how these two invitations came to me. First, however, I must say that such an arrangement made me conscious of the importance of the attitudes and approach I would take with me as I moved among the peoples of my host countries. It seemed quite reasonable to me to expect to receive no better or no worse than I was ready and willing to give.

Without a doubt my travel in East Africa posed far more challenges to me than my travel in the USSR. The reason is easy to understand when one considers that my tour had been arranged by the Educational and Cultural Division of our own Department of State. And I was being presented to East African audiences through the joint cooperation of East African schools and local groups with the United States Information Service. However, the United States Government had a problem.

My tour had been scheduled at a time when our nation, especially the southern part of it, was embroiled in ugly clashes between blacks

and whites over the latter's denial of civil rights to the former.

According to the stated plan my assignment indicated that my job overseas was to discuss my profession with groups of artists and art students. But an even heavier emphasis was to be given to my special skill with "chalk talks." A chalk-talk artist is one who communicates ideas easily and interestingly by sketching quickly as he talks. Effectively done, the chalk talk becomes a memorable showpiece. And through such sessions it was presumed that I could be effective in helping to establish lines of international friendship and good will. On the planning sheet it all seemed so neat—so pat.

For those who believed that my talks in East Africa centered exclusively upon the subject of art I have a surprise. Because I am a black American I knew, without having anyone tell me, that I would have yet another job to do. I was going to be asked aboout American racism. More than that, my questioners were going to look to me for some pretty straight answers.

Not much had been said about that certainty in Washington before I left to go on tour. No one there had to say much. They knew and I knew just how important such discussions would be to any group of foreign students, particularly if they were nonwhite and *most* especially if they were black. Because I have been black for a long time I felt that engaging in such discussions might well be my *prime* job.

Moreover, I knew that any attempt of mine to evade or dismiss the subject would be not only personally disastrous but personally unthinkable. While I certainly have the normal man's share of fears, such moral cowardice is not one of my problems. There would surely be African students and scholars in my audiences who would believe that I was being sent to them as an "Uncle Tom apologist" for the wrongs visited upon black men by white men. Well, I am nobody's "Uncle Tom." And I shall relate how I handled that situation in the pages that follow.

The opportunity to visit the Soviet Union came under circum-

stances that in no way involved me with any branch of the United States government. A quite unexpected invitation from the Union of Soviet Writers via the quarterly magazine, *Freedomways*, reached me just as I was completing my biography of Marcus Garvey.

For several years I had contributed drawings and writings to *Freedomways*, a splendid though impoverished "magazine of the freedom movement" published in New York City.

In spite of lack of advertising and the usual gimmicks upon which commercial magazines depend for survival, *Freedomways* has weathered a few crises in the more than ten years of its existence. Along the way it has earned the attention and respect of the major American universities and colleges who are among its subscribers. And like other good periodicals, *Freedomways* has admirers abroad. Some of them are in the USSR.

So I leaped at the invitation to visit the Soviet Union as one of three black Americans guests of Soviet writers, well aware, as are other scholars of the world, of those special problems with which we nonwhite Americans are obliged to deal. Moreover, my enthusiasm for the trip was occasioned by more than the normal human desire to see strange and unfamiliar places.

I happen to believe that it is the duty of artists and scientists to grasp every opportunity to explore and learn. Indeed, the arts and sciences impose upon their practitioners the obligation to maintain a relentless search for as many fragments of truth as we can find. Then we have a final duty to perform. Having gathered whatever fragments of truth we can, we must share our findings with others. That is what being an artist or a writer is all about. And that, too, is precisely what I am about as I offer the following, for whatever it may be worth.

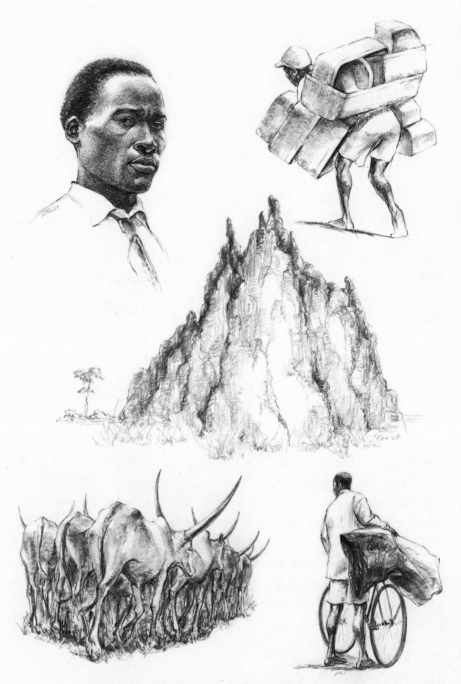

VIGNETTES OF UGANDA WITH ANT HILL IN CENTER

1

UGANDA

"What a lovely jewel! Surely this is the pearl of Africa." Such was the spontaneous description of Uganda offered by an English explorer who saw it for the first time more than a century ago. Over the years that East African country, slightly smaller than the state of Oregon, has lost none of her loveliness. Surrounded north, south, east, and west by the Sudan, Rwanda, and Tanzania, Kenya, and the Congo Republic respectively, this little nation is a veritable agricultural Eden. It is often said of Uganda that none of its inhabitants need ever die of starvation. One is inclined to believe that, as he views the abundance of food-producing land and cattle.

Most of Uganda is a temperate plateau rising to an average of four-thousand feet above sea level. Her waterways include Lake Victoria, source of the Nile; and her two national game parks, Queen Elizabeth and Murchison falls, are hosts to some of the most handsome flora and fauna in all Africa. Of the East African countries I visited I found Uganda the most alluring. And as is true of many beautiful ladies, Uganda's beauty is either directly or indirectly responsible for much of her woe. Covetous explorers and expansionists have been unable to resist her combination of wealth and good looks.

Virtually all of Uganda's ten million people are black. They represent sixteen major tribes of which the Buganda tribe is the largest.

But in spite of their superior numbers black Ugandans have been overshadowed in their own country by smaller groups.

First there are the British, of whom there are scarcely more than seven thousand, who function in Uganda as teachers, civil servants, and technicians. They retain their British citizenship and their numbers are augmented by about three thousand Europeans from other countries. The only group in Uganda as small as that of the Europeans is the handful of supervising black elite. They include the president and his cabinet, and a few intellectuals, politicians, professionals, military heads, technicians, and regional chiefs. The rest of the black majority population represent the working class.

Next to that tiny but powerful English clique the most aggressive group in Uganda until 1972 was its eighty-thousand Indians, referred to throughout East Africa as "Asians." Ten years earlier when, in 1962, the country declared itself independent, only a trifle more than one-third of those Asians chose the Ugandan citizenship offered them. But they faced a showdown in 1972. Uganda's strapping black military president, Major General Idi Amin, issued an order expelling noncitizen Indians from the country.

Accusing them of being "saboteurs of the economy who have milked the cow without feeding her," General Amin's controversial stand and the events precipitating it will shortly be related in greater detail. Meanwhile, a brief look at Uganda of a century ago will be of aid in understanding many of the events that have currently been happening there.

It was 1862 when British explorer John Hanning Speke arrived in the kingdom of Buganda, close to what is now the Ugandan capital city of Kampala. Speke, who along with James Grant had led a controversial search for the source of the Nile River, did indeed find it at Lake Victoria. He was followed by Protestant and Catholic missionaries, some of whom offended Ugandan chiefs, who accused them of meddling in the political affairs of their tribes. Then came Frederick Lugard.

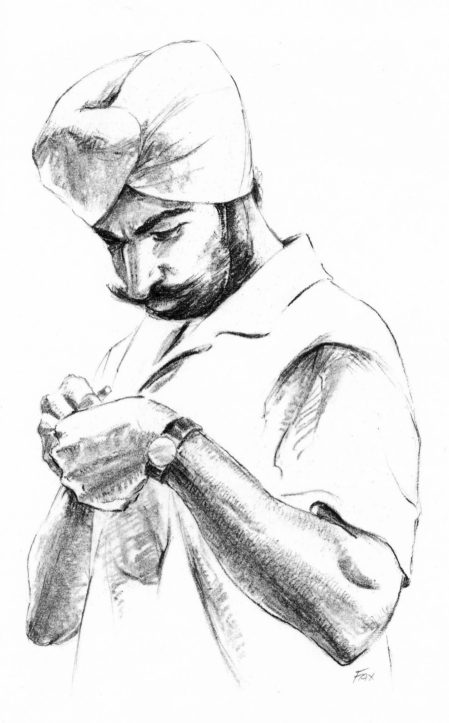

AN ASIAN ARTISAN, UGANDA

He was the Madras-born son of a British clergyman. As a young man Lugard saw military service between 1879 and 1880 with the far-flung British armies in Afghanistan, the Sudan, and Burma. He then entered the service of the British East Africa Company. There Lugard's prime duty was to wage an unrelenting campaign against native rulers whose interests conflicted with those of the Company. Meanwhile, the Berlin Conference of 1886, at which Africa was carved and parceled out to its European participants, awarded a sizable portion to Britain.

Lugard quickly brought the Buganda kingdom under the control of the East Africa Company. And by 1894 Great Britain had proclaimed an official protectorate over that territory, as well as over several neighboring regions. From then until 1962 the four traditional kingdoms, along with the old districts of the area, became the East African British colony called *Uganda*. Its name was derived from the nineteenth-century Swahili form of "Buganda."

There are those who view the colonialist solely in the Sir Galahad role of savior of an inferior and benighted people, dominated by their own feudal rulers. To others, the colonialist is nothing more than a blatant thief and exploiter who, at best, only clumsily masks his true role as he goes about the nefarious business in which he is engaged. Obviously there is truth and falsehood in both descriptions.

However one feels about colonialist expansion in East Africa, no one denies the need for the industrialization it has introduced to a formerly agricultural land. Prior to colonialism, travel there was far from comfortable and accommodations far from adequate. Today's modern industrial and political exploiters, as well as scholars and those who go simply to gawk and to play, find travel in East Africa infinitely more pleasant than in the days of Stanley and Livingstone.

Uganda's modern airport is at Entebee, and Entebee is linked to Kampala, the capital city, by twenty-one miles of good macadam road. The panoramic views of the countryside en route are stunning.

Adjacent Lake Victoria, broad and majestic, ripples invitingly as one views it from the crests of sweeping green hills. Foliage is thick and heavy. Birds of all sizes, their plumage afire with color, flit among the eucalyptus and pawpaw trees. Flame trees spread their vermilion branches against the multigreen background, and the entire landscape undulates under warm tropical skies.

Kampala, once the residence of the kabaka of Buganda, is a modern city of about three hundred thousand; its population has within recent years been dominated by Indian merchants. Indeed, prior to 1972, had one entered Kampala for the first time on a Sunday afternoon, one would have wondered if one were in an Indian city. At such times the residents promenaded in their finery. Saris of all colors and patterns mingled with the soft ankle-tight pantaloons of the

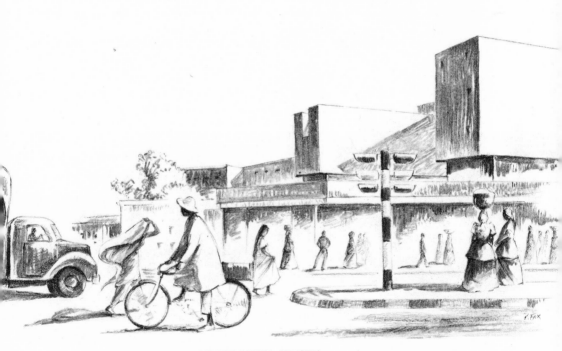

KAMPALA STREET SCENE, UGANDA

Pakistan women and the turbans of the bearded men to create the air of an Indian capital.

During the week Kampala swarmed with Africans. I saw them carrying burdens, riding bicycles, and driving cars. And I saw them in the shops and office buildings throughout the city. But at the end of the working day the exodus of Africans to the outlying areas of Kampala had for years been a daily ritual. I have seen them cramming the buses, cycling, and trudging to their prescribed sections as they abandoned the city to the Indian merchants whose business firms were evident throughout Kampala. How did such a situation evolve?

I said earlier that many of Uganda's problems are traceable, in some measure at least, to her natural wealth and beauty. Early British explorers took careful note of both, and when their government was ready it made its move. "Developing the newly acquired East African territory" meant developing it for British gain, first and foremost. Any good accruing to the colonized people was incidental. So the British began making this newly acquired rich and lovely prize accessible through the building of a railroad.

Such a project required technical know-how, which the British had. It also required muscle, which the British also had but did not choose to use in that manner. Of course, she might make use solely of the native muscle right at hand. But Britain had not earned for nothing the name of the most successful European colonizer abroad.

You have to be careful when you are a minority in want of, or in need of, something held by a hostile majority. If the methods you use in trying to get your hands on that something are crude and bungling you will not only fail but probably perish in the process. Perishing in the course of empire building, though not unheard of, was not in the British plan. While exposing herself to a minimal number of bad risks, she simultaneously found ways of advantageously shifting the troublesome weight of her problems. In East Africa she could achieve her aims through a method that rarely fails a clever minority. Why not set

up a situation combining constructive work with just enough discord to divert the attention of the majority away from her own selfish aims?

Great Britain turned to the East. There, in her Indian colony, she saw the kernel of the solution to her immediate need in East Africa. Ever since 1600, when the British East India Trading Company was formed, Britain had established her interest in India. A century and a half later Britain had reached her point of ascendency there. In yet another century she had succeeded, through sharp trading and frequent and effective use of guns, to control both external and internal forces of conflict detrimental to her Asian interests.

British power in India, however, did little to prevent the frequent famines that beset the land. One engulfed southern India between 1876 and 1878. That was followed by the great famine of 1899–1900. And hungry Indians seized upon the British move to send them to East Africa where food and work were assured. Great Britain was ready to build its railroad connecting the British colonial city of Kampala in Uganda to the British colonial seaport city of Mombasa in Kenya. The line would connect more than five hundred miles of handsome East African soil, rich in cotton, tea, coffee, and sugar. The Indians with concave bellies would be an effective labor force. Moreover, they could very well provide the buffer group needed to hold the restive African majority in check.

They began to arrive between 1889 and 1902, these first labor imports from Hindu India and Muslim Pakistan. And though their's was not an enviable existence in those early days, they were held together by the desperation of the hunger that had driven them from the unbearable familiar to the promising uncertainties of a new land.

They worked hard and they were clannish. They took special care to have little or no social contact with the indigenous Africans. Their religions, customs, dress, and language enabled them to establish and maintain an aloofness that was to be, ironically, the pinnacle of their

HINDU TEMPLE, KAMPALA, UGANDA

strength, and the root of their undoing. In a generation many had succeeded in accumulating enough through hard work to embark upon other more independent ventures. They opened shops (*duka-wallas*) as artisans and tradesmen providing services and goods to their respective communities. Because European settlement was small in Uganda, the majority of the Indian clientele was black.

How could that happen? Why did not Uganda's Africans themselves become the internal traders of their country? Was it because they were too lazy, ignorant, unreliable, and unwilling to work together? Or was it because they simply did not have capital or credit, either or both of which the merchandiser must have?

The agrarian African has traditionally worked his land in order to exist, so pure sloth could not have been the reason. Besides, it is part of his cultural tradition to work and to live collectively. As early as 1913 a few Uganda farmers marketed their cotton crop cooperatively for the purpose of getting a better price for it. So just where was his point of weakness?

Wherever the transition from the old subsistence moneyless economy to the cash crop economy has taken place, it has been accompanied by the emergence of the creditor and the debtor. The worker or producer of goods who can neither read, write, nor cipher, and who, in addition, is unused to the ways of the wily, is destined to become a debtor. So the illiterate and inexperienced Uganda growers became fair game for the clever, fast-talking, double-dealing buyers and traders. Soon the grower began to owe *them*, and in the effort to "catch up" he mortgaged future harvests. His plight paralleled that of the sharecropper of our own rural South, and ultimately he was denuded of all incentive. He had no capital, and what few surplus goods he acquired he had no way of storing.

While the literate and more sophisticated Asians were scrimping, pooling their capital, and establishing their credit, the Africans could obtain no credit. The latter were compelled to work and for minimal

wages, while the shrewd Indian small-shop trader readily extended the desperately needed credit to him. Yes, his own illiteracy, ignorance, and inexperience in the early part of this century were the great hindrances to the African aspiring to be a trader.

Parenthetically, there is today a growing class of African traders. And none is prouder and more critical of them than the enlightened African, who constantly reminds them to observe the principles of integrity, dependability, and gumption in their business transactions.

Between the 1920s and 1930s a second Asian immigration, encouraged by the success of their predecessors, arrived from the East. They too began to prosper. Asian clannishness sprouted into arrogance with growing Asian wealth. Exclusive Asian schools, residential districts, clubs, and places of public accommodation began to appear. Invariably they were far more comfortable than those of Africans. Profits that swelled as a result of the shrewd and ruthless exploitation of black labor and clientele were often smuggled by Asian merchants out of Uganda. And as the capital city of Kampala continued to grow, the presence of Indian businesses and residences increased.

The city's shops, garages, and hotels were all manned by Asians. Doctors, lawyers, architects, food distributors, and teachers were Asians. Africans worked for Asians at wages generally far below a fair standard. And as African employees began to master the skills of their Asian bosses, they found that their wages, instead of increasing, often remained at the level of the unskilled. Partnerships between Asians and Africans were rare, if not unheard of. And schools and housing for Asians and Africans were separate and unequal.

This conflict between black and brown men suited the British purpose. The buffer group they had created was functioning well, as became more evident with the rumblings of discontent vibrating through the country. Black resentment was swelling. Africans had seen Kampala completely taken over by Asians. They were painfully aware that 90 percent of Uganda's trade and commerce, worth nearly 3000 million dollars, was in Asian hands.

BLACK UGANDAN

ASIAN UGANDAN

Uganda's black leaders earnestly began to agitate for black independence. They wanted independence first from British colonialism. With that in their grasp, they would then break the Asian economic stranglehold. The struggle became intense and bitter. Stiff resistance to Uganda's moves toward self-government were, understandably, opposed by both British and Asian interests. But African rage reached its peak when, during disputes with the British over the issue of African independence, the Asians (who have never been accepted by the British on terms of equality) arrogantly stood on the side of the British.

That did it. When in 1962 Uganda became an independent state, the black president and his cabinet offered Ugandan citizenship to Asians. There was, however, a binding condition. As citizens of the newly formed state, Asians, along with Africans, would be accountable to the new black government.

Of Uganda's eighty thousand Asians, twenty-five thousand accepted the terms. The remaining fifty-five thousand applied for British passports without making any effort to leave Uganda. Again the Asian arrogance was asserting itself. But their decision to bluff it out, if possible, even as they hoped the British would gladly open the doors in an emergency, was as haughty as it was naïvely wishful. General Amin did evict them in 1972, and British hospitality has so far proved to be far from warm. Somewhere along the path to their success in Uganda the ambitious Asians seemed to have lost sight of the true character and purpose of British colonialism.

I had seen and felt some of the tension in Uganda. And as a black American, familiar with patterns of bias in which race and color are used to the advantage of one group and the disadvantage of another, I understood what I was seeing. Indeed, my very first speaking engagement in Kampala was at the old Kampala Senior Secondary School. A former colonialist government institution with an exclusively Asian enrollment, I found it to be still mainly Asian, with a minority of

Africans and Europeans sprinkled through its classes.

I found the class of eighty or so art students attentive and politely responsive to my sketching and related oral comment. Their studio space and working materials were more than adequate, and they confined their queries and comments strictly to matters of drawing and painting. Before I left them that day their friendly Indian teacher insisted that I must revisit them before leaving Uganda. What a contrast they and their environment were to the nearby Lubiri Secondary School.

Lubiri was shopworn, dingy, crowded, and black. Walking through its narrow, musty hallways to the meager art room pulled me back over a time span of forty years. Those were the uncertain days when I passed from one class to another in my own congested and poorly equipped jim-crow high school in Maryland. An air of bittersweet familiarity clung to the very walls of Lubiri. Though the accents differed from those of my black fellow Marylanders, the soft, rounded tones of black voices were the same. And ten minutes after I started addressing myself to the slight, onyx-hued teacher and his students we began to sail together through the warm waters of fraternity. Then we became engulfed in far more than the stilted rhetoric of shoptalk. They questioned me.

"What is your African name and from what place in Africa did your people come?"

"Why don't our black brothers and sisters in America return to their native homeland?"

"We are great admirers of Dr. Martin Luther King. Is he a personal friend of yours?"

"You have great skills yet you are not a European nor do you resemble what we think of as an American. You must be an African."

Such was the direction of their interests. And they were but a prelude to what I was to see, hear, and feel in other parts of Uganda. Thanks to the imagination of the alert, black assistant cultural-affairs

HEADMASTER (RIGHT) AT ST. HENRY'S SECONDARY SCHOOL

officer, Horace Dawson, I was slated to travel more than fourteen hundred miles through the countryside before leaving that "Pearl of Africa."

Dawson is a native Georgian. I soon learned that though he was a first-rate United States Foreign Service officer, he has never forgotten what it is to be a black American. There was much for me to learn from this man as we rode with our African driver, Sam Nsubuga, through each of Uganda's four ancient kingdoms.

There was that memorable stopover in Masaka, a town eighty miles southwest of Kampala. Our first contact in Masaka was with the students and staff of the Saint Henry's Catholic High School for boys. To my surprize we encountered there the one and only *African* headmaster of the many schools at which I appeared in Uganda. British men and women, traditionally East Africa's educators, were in control of that critical area of the nation's development. And how some of them resented anything resembling an intrusion by others!

Horace Dawson warned me that we could very well encounter some British resistance among school administrators as we traveled through Uganda. Though the invitation to address ourselves to secondary school groups had come through the new Uganda government, we still had to get past the British headmasters. And while some were cordial and hospitable, others were not, as will be seen. But here we were in an unusual situation at Saint Henry's, the majority of whose staff and enrollment was black. Here indeed was living proof that trained Africans can and do supervise their own programs.

Still, Africans, like others, have their share of human weaknesses. Indeed, before we could get out of Masaka I had a good look at an African whose exposure to British conditioning had left its mark indelibly upon him.

We were introduced to the man by a young, white American couple teaching in Masaka. Obviously they thought more highly of him than did either Dawson or I, but tastes in people, as in everything else, do

vary. He was short, fastidiously dressed, and more pompously British than the British themselves. I had an acid-tongued aunt who pinned the perfect label on men of his type—pipsqueak. His name is not important here, and since he was a professional man I shall call him "the Doctor." In addition to his regular professional pursuits, the Doctor, because of his family's middle-class standing, also held a civil post enabling him to hire and fire poorer Ugandans. Fortified by liberal samplings from our hosts' whiskey bottle, his monologue zeroed in on his importance in the community.

For fully an hour Dawson and I maintained a diplomatic silence as the Doctor dammed the "incompetence" and "unreliableness" of blacks, while extolling the unlimited virtues of whites. He concluded

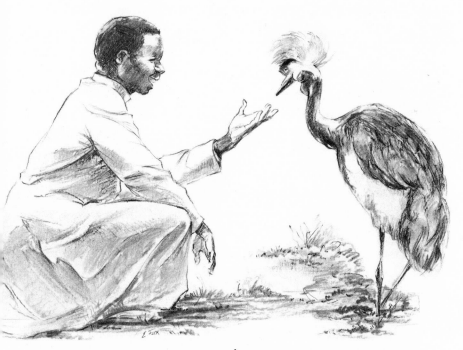

TEACHER AT ST. HENRY'S WITH CRESTED CRANE

with a special tribute to British female secretaries who, in his judgment, were unsurpassed both during and after office hours. As we parted company with the Doctor I was convinced that the highly publicized "toms" of this world are by no means confined to either America's black communities or her turkey farms. The Doctor's deportment was, of course, but a caricature of the arrogant British colonialist, whose airs he sought to emulate. I encountered the real thing itself while in Uganda and I had my chance to show what I thought of it.

It happened at Mbarara in the kingdom of Ankole, eighty-five miles southwest of Masaka. We were expected at the Ntare School for Boys and because Horace Dawson believed in promptness we arrived with nearly a half hour to spare. The headmaster, a Mr. Crichton, had been notified well in advance of our coming, as all arrangements had been previously made with him by Dawson. We were curtly told by an office clerk that we would have to wait. For almost fifty minutes we waited. Finally Mr. Crichton sauntered in. Without a word as to the reason for the delay, he curtly greeted us and asked if we were ready. As he paused to issue orders to his office clerk I looked him over carefully.

He was of medium height, wiry, red-necked, and colonial British in manner. He didn't speak with his assistants. He tossed directives at them. His crisp, starched whites accented the leathery redness of his skin, and both seemed quite in harmony with the merciless sharpness of frigid blue eyes. I later ventured to make a comment to him and put my foot in it by inadvertently mispronouncing his name.

"The name is Cryton," he icily corrected me. "But *you* would hardly be expected to know that," he added. I was stung. Moreover, I was absolutely furious with this man from whose every pore oozed the venom of arrogance. I resolved to get in my licks for that insult. But I'd do it in a way that would not cast me in the role of the rude and quarrelsome guest. I would wait until I was on the platform and

from there I would commit a little emotional arson among his African students. Then I would slip quietly away, leaving Mr. Crichton to extinguish the blaze.

It did not take long to get the fire going. After reminding the students that my own country had also been a British colony, I remarked that from that viewpoint we Americans held much in common with them. We *black* Americans, I added, had an additional tie to them by virtue of having been dragged from their midst in chains, to a land where the validity of our African heritage was denied. I told them of jim crow, of lynchings of the body and the spirit, and of the distorted view of Africa we had been given by those who exploited both them and us for profit. And when I was through the students beseiged me for more. Mr. Crichton and his staff, meanwhile, had disappeared.

A trifle more than three years later I chanced to meet one of those young men from Ntare School when we were both in Boston. He was there on a scholarship to the Massachusetts Institute of Technology. Seated beside me at dinner, he looked at me and shook with mirth. He said, "You know, sir, when I left Ntare some of the boys were still talking about that day you dropped your bomb on headmaster Crichton!"

There was the delightful meeting with proud woodcarver Odomaros Kanyoma, who earned his living as the janitor at the Butobere College in Kabale, down on Uganda's southwest border. Odomaros was an artist, a really genuine and creative force. He wasn't heralded; and he wasn't attached to any of the shops and studios whose craftsmen are kept busy turning out truckloads of those commercial "African carvings" one buys at the airports and gift shops from Nairobi to New York City. I don't believe he or his work would interest those who sell and buy such stuff. Nor did they interest him.

No, this was an original man. He was a folk artist without formal training who saw life and interpreted it in his own strong way. To do that he chose to sweep and scrub behind the students at Butobere.

ARTIST ODOMAROS KANYOMA OF KABALE

Without pretensions or delusions, he gracefully filled his blue-collar role as clean-up man, and when he set aside the tools of that trade, he resumed his drawing and carving. This man was so sure of his strength he did not have to try to impress. He was free. I've known a few artists like Odomaros and I respect them profoundly.

How different was the young black hotel clerk we saw later at the hotel in Fort Portal, a hundred miles away to the north. His shirt was starched and white and his black necktie quite properly in place. His pretensions protruded like the quills of a porcupine. The hotel was typical of those of the East African bush. At a given hour of the evening the electric current was shut off and guests were obliged to use the furnished candles for light. But then the hotel provided no matches. There *was* hot running water, however, and the charge with three meals ranged from eight to ten dollars per person per night.

Dawson and I encountered the clerk as we checked out at 6:30 A.M. He was alone at the desk, and though he was pleasant, we had the feeling he was overdoing the British manner. We asked how much we owed.

"I don't know, sir."

"Well, who *does* know?"

"The manager, sir."

"Where is he?"

"He is sleeping, sir."

"Well, please wake him up and find out what we owe." The young man's self-assurance vanished.

"I can't do *that*, sir."

"Why not?"

"Why, it would *disturb* him, sir."

The clerk was making it crystal clear that the very thought of disturbing his boss was unthinkable especially since he was being asked to do so by two *black* men. We tried another angle.

"Look, we have to leave *now*. Won't the manager be even more

disturbed if *you* let us go without first getting his money for him?"

That really shook the poor fellow. His shoulders drooped slightly as he reluctantly disappeared to the rear of the hotel. In a few moments he was back to announce we owed fifty shillings ($7.00) each. We knew better than to offer him a large bill, for he would have to re-awaken the boss for change. So we gave him even money. When we asked for receipts, he had no key to the desk where receipts and similar valuables were kept. After some scrounging in our own pockets, we produced paper upon which he quite legibly and literately made out our receipts.

We pitied that young Ugandan, though we knew full well he considered himself to be far better than the likes of Odomaros, who swept and mopped for his bread. Yet this clerk with his literacy, white shirt, black tie, and British accent was enslaved and completely powerless. The British lion, even a sleepy one, could devour him any old time he chose to do so.

Thus the specter of colonialism continues to haunt the lives of many "free" Ugandans. I recall the distinguished-looking Uganda physician, trained in America, and a long-time resident of New York. He had happily returned to his homeland, when independence came, with the expectation of "helping his people." Moreover, he had managed to assemble sterilizers and other much needed equipment, which he had shipped from America to Uganda. The doctor arrived and I saw him there. The equipment also arrived, though I did not see that. But from what I learned through a reliable U.S.I.S. source in Kampala, it was held up by Uganda officials who, for reasons best known to themselves, refused to release it. After a time the disillusioned medic returned to the United States.

Dawson recalled the all-night gas station attendant left to work completely outdoors with no money for making change. All tools and equipment were securely locked inside the station, to which the attendant had no access. When it rained, the chap had to find whatever

UGANDA WOMAN

shelter he could until the boss appeared in the morning to open shop and collect whatever was due him.

I laughed bitterly at Dawson's unflattering description of the British housewife whose formidable collection of keys included those to her refrigerator and food closet. Her African cook had to accept what madame *chose* to dole out from meal to meal. Oddly enough, while madame declared how little Africans appreciated British tastes in food, she was never sure her underpaid cook would not filch any of hers.

Such incidents are but symptoms of the larger truth that Uganda, along with the rest of Africa, is all but totally dependent upon the Euro-American world. Black American poet Charlie Cobb, a resident of East Africa, puts it succinctly in his essay, "African Notebook: Views on Returning 'Home,'" published in the May 1972 issue of *Black World*. Says Cobb:

European industrial and military might exists because of the exploitation of Africa. It is not an accident that African nation-states must attach their various currencies to European currencies in order that theirs may have value.

Still, official and nonofficial Africans everywhere are constantly challenged to "measure up to your responsibilites as free nations." The truth is that while African nations carry a full load of very real responsibilities, African freedoms are largely illusory.

Bearing responsibility without the power of *authority* that dignifies and strengthens that responsibility is the common experience of many *officially* liberated slaves, serfs, and colonials throughout the world. While they do welcome the varying measures of relief that accompany the new status, it is folly for them or anyone else to believe they are free. No people are free as long as their destinies hinge precariously upon the needs, desires, fears, or caprices of others who occupy positions of power over them.

That is what I observed as I was privileged to travel in East Africa. Uganda was the first stop. There I recall that one of the most influential enterprises in Kampala was Barclay's Bank. Barclay's is a *British* —not an African lender and investor.

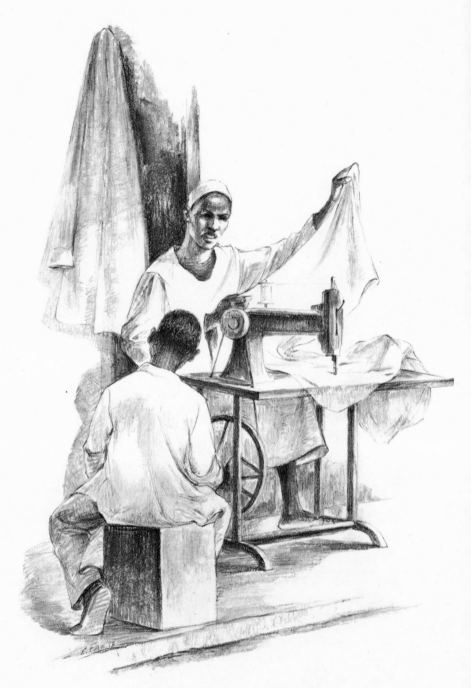

SUDANESE TAILOR—KHARTOUM

2

THE NORTHERN
SUDAN

I soon learned on this tour that the character and personality of the American Foreign Service officers with whom I worked had much to do with shaping local attitudes I found upon my arrival. By "local attitudes" I mean not just those of officials having direct contact with our overseas officers, but also those of nonprotocol citizens who were concerned with what our representatives were up to in their countries. Where our Foreign Service officers are liked and respected, they and their programs may expect a friendly reception. The opposite is true of those not liked and not respected. So as a transient specialist invited to help our officers in East Africa with their programs, I had to be sensitive to the existing local climates.

I had not been in Khartoum twenty-four hours before becoming aware of tension. It was not directed at me, personally, though I felt the initial vibrations as soon as I met with our public affairs officer. After greeting me with a perfunctory handshake, he asked me to describe my presentation. I thought that rather odd, inasmuch as advance word of the work of specialist grantees usually spreads quickly through the network of our overseas outposts. However, I described my program in a few brief sentences. The Officer leaned back in his

chair and looked vacantly out the window while tapping his fingertips with a letter opener.

There was a cool finality in his measured reply. "We have little need here for that kind of presentation. You see, this situation differs from that of Uganda and the other countries you will visit."

I listened carefully as he continued. "Here the Arabs are dominant and they hate the Negroes who live in the southern part of this country. The Arabs are determined to dominate the Negroes, who are rather backward. Of course it must be admitted that the Arabs are far more intelligent and therefore more ambitious. Still, things are in a bad state inasmuch as Arab cruelty to Negroes is colossal. So with this racial trouble here we have made no arrangements for you to travel south."

For an instant I wondered if I had been hearing correctly. I then ventured a question. "Have you been troubled here with challenges from Sudanese students about our own race problems?"

"None that I can recall." Then very quickly: "We have arranged for you to visit the art department of the Technical Institute and then to visit the Women's Bazaar at the Sudanese Cultural Center. I think you will find both places interesting."

My brief conference with this man was over, and though I had to respect his position as a key Foreign Service officer, I could not fully believe what he had told me. I had been looking intently at the people of Khartoum from the moment I had arrived. Most of them were black. There were varying shades of brown among them and hair textures ranged from straight to kinky. It was also obvious that they were of the Islamic faith. Few resembled my artist's concept of Arabs, "swarthy skin, fairly sharp features, piercing grey or brown eyes, and straight or curly hair." A highly visible few did vaguely fit that description. But the vast majority I had seen so far, at the airport, on the streets, in the hotel, looked more like blood relatives of mine. To the best of my knowledge, few of *them* are likely to be mistaken by any well-traveled white American for Arabs.

Still I was puzzled—and a bit embarrassed. Had the officer told me
something I should already have known? Should I have done my
homework more carefully before my arrival? For the second time I
went through the material issued me in Washington until I located
the briefing sheet on the Sudan. Under the section titled: "Size,
Population, Ethnic Groups, and Religion," I read and reread the fol-
lowing paragraph.

In the country as a whole, some nine million largely Arab-speaking
Moslems live in the six Northern Provinces of the country while the re-
maining three and a half million which are largely pagan tribesmen inhabit
the three Southern Provinces (Bahr el Ghazal, Equatoria, and Upper Nile).
There are some Christian groups throughout the country.

So *that* was it. These people I had been looking at and listening to
were bilingual, speaking both English and Arabic. They were a mix-
ture of Arab and black African and they were loosely referred to as
"Arabs" because of their ethnic mixture and Arabic tongue. There was
no reference whatever in the official memo to "Negroes." That term,
used by my interviewing officer, had obviously stemmed from his
personal interpretation of what it implied to *him*.

It is a term to which Americans have become accustomed. Unhap-
pily, many have been warped by what the word means to them. For a
moment I felt a little less confused. Then it struck me that there was
something almost comically twisted in this whole silly business of
arbitrarily pinning labels bearing unpleasant connotations upon peo-
ple who happen not to look like you and yours. I immediately recalled
being introduced to Ahmed Omar shortly before that meeting with
the officer in charge.

Ahmed was a local assistant and liaison man attached to the
U.S.I.S. in Khartoum. His work included seeing that visitors like me
were transported to various places in the city and that arrangements
for our programs were kept in order. Ahmed was tall, slender, as
nappy haired as I, and a couple of shades darker. Was he also one of

the "cruel Arabs" who persecuted Negroes from the southern portion of his country? I'd have to ask him about that.

Besides, I began to wonder if my own designation as a "Negro" by my white fellow countrymen would make any difference to Ahmed and his fellow Sudanese. If they thought that I, too, was deserving of Arab scorn, why on earth would they invite me there as their guest? And why, if the American embassy officers felt that being a "Negro" as opposed to an "Arab" was not such a good thing in Khartoum, was I brought there as a representative of a branch of American culture? Or was I supposed to be something quite extra special in Negroes?

The more I thought about it, the less sense it made. So I decided to proceed with my work as I felt I should. Questions about white racism in America would surely come from our Sudanese hosts, and I resolved to answer them forthrightly. I did not have to wait long for the chance.

Walking slowly through the heat beneath the welcome shade of whitewashed eucalyptus and labakh trees flanking the banks of the Blue Nile, I began to contemplate the history of this legendary place. Known as "Nubia" and sometimes "Ethiopia" during the days of ancient Egypt, the northern Sudan in particular was quite familiar to Egyptian pharaohs who established their own fortified settlements there. Beginning 3000 B.C. and extending over fifteen hundred years, Egyptians, directly to the north, entered the southern territory as traders and seekers of gold. The name "Sudan," meaning "Land of the Blacks," did not fix itself to the area until the nineteenth century.

In those days it became known formally as the Anglo-Egyptian Sudan, and with good reason. Both Egypt and Great Britain occupied Sudan's territory. The Egyptians, with British backing, came first and remained for forty-one years between 1820 and 1861. During their rule the Egyptians sought to break the power of Sudanese Islam, and to destroy their trade in slaves and eventually their economic and political life. The former effort outraged Sudanese religionists; the

latter threatened the very existence of the Sudan. Egyptians, them-
selves former slavemasters, held little feeling for the fact that the
Sudanese would not willingly relinquish political strength by meekly
surrendering their human property.

In 1881 the Sudanese found a hero around whom they could rally.
He was Mohammed Ahmad ibn as-Sayyid Abdullah and he declared
himself the long-awaited and divinely sent Mahdi, or spiritual ruler.
He would restore Islam to its rightful place in their land. The popu-
lace flung itself into a frenzy of joyous fanaticism behind the Mahdi.
They promptly drove the Egyptians out.

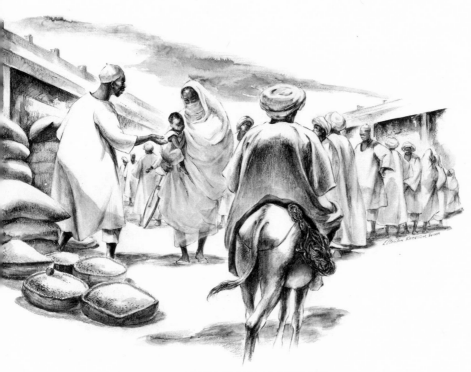

MARKET PLACE, OMDURMAN

From 1881 until the Mahdi's death four years later, the Islamic forces ran rampant. They captured Khartoum, killed and repulsed Egyptian troops, and succeeded also in killing the British commander in Khartoum, General C. G. Gordon. And though the Mahdi died at Omdurman shortly thereafter, the control of his rule went to Khalifa Abdullahi, who headed the state well through 1896. Then came Horatio Herbert Kitchener.

He was born in County Kerry, Ireland, of Protestant English parents during the middle year of the nineteenth century. His military training, coupled with a cold, celibate nature, made young Kitchener the perfect colonialist crusader. He would go anywhere and destroy anyone or anything for love of God and country. To Christian soldier Kitchener, the non-Christian hordes of the Sudan *had* to be destroyed. His zeal to accomplish just that was sharpened with the killing of General Gordon, and Kitchener fairly itched to get on with his holy mission. His chance came in 1896.

Three years later the Mahdist strength was broken and the Anglo-Egyptian army under Kitchener's leadership was in command of the territory. For one year Kitchener served as governor general of the Sudan until lured to another battlefield in South Africa. The nineteenth century had just reached its end.

For the next half century, until 1954, Britain actually dominated the administration of the Sudan, forming its policies and supplying most of the administrative personnel. Meanwhile, however, she was careful to create the *appearance* of a joint administration with Egypt. But the real state of affairs was reflected in the restlessness of military and civilian dissidents.

Mutinies among both Egyptian and Sudanese troops began to harass the British. And with Sudanese participation in World War II against the Italian invaders of Ethiopia to the east, a strong nationalism took root in the Sudan. In 1953 both Britain and Egypt signed an agreement that the Sudan had a right to self-determination.

Three years and a bloody army mutiny later, in which scores of civilian lives were lost, the Sudan, even with its northern and southern areas torn asunder, became free. Today, that country, Africa's largest land area, and her fourteen million people are officially independent. Ten million of her population are Muslims, inhabiting the six northern provinces. The rest are largely pagan tribesmen with a sprinkling of Christians.

KHARTOUM VENDOR

It was a typically hot April morning the day I visited the Women's Bazaar in Khartoum. Ahmed Omar was to pick me up shortly after 8 A.M. and take me directly there, and it occurred to me that I'd get a chance to chat with him—alone. Everyone and everything wisely got started early in the morning during the hot, dry, spring weather, as was apparent the instant I left the air-conditioned building. A wave of torrid air hit me with a terrific wallop, though the throngs of pedestrians and motorists seemed unaware of its intensity. Especially oblivious were the quick-stepping donkeys and occasional ambling camels, who were as disdainful of motor traffic as they were of the heat.

Men clad in clean, white, loose-fitting robes and turbans, and women wearing long, white, full-fashion skirts, blouses, and veils, passed quietly along the streets. All wore sandals. Only the dark eyes and dark brown hands casually holding the veils in place were visible among the women. Still not convinced of my infallibility, I continued to look carefully into the faces of the men. Most of them were black and subtler shades of dark brown, with features ranging from rounded and flat to near aquiline. The same people walking in Harlem or Watts or along Chicago's southside would, except for their gleaming white clothing, attract little attention. My reverie was interrupted by Ahmed, who had come to take me to the Cultural Center.

"It is nice to have you here, sir." Ahmed smiled pleasantly as he led me to the car parked under the merciful shade of a tree. I asked him where he was born.

"I am Sudanese, sir, born right here in Khartoum."

"You speak Arabic as well as English, don't you?"

"Oh, yes, English and Arabic are *both* our official languages, you know."

We stopped for a traffic light. Two young fellows crossed in front of us. Unlike the other men, they were not dressed in white robes or in turbans, but in shorts and soiled, tattered shirts. Like Ahmed and me they were black and their features rounded and flat. A procession of

tiny gold rings adorned the upper edges of their ears. I asked if they, too, were Sudanese.

"Yes. They are from Southern Sudan and they are laborers."

"Do they speak Arabic?"

"Oh, no. They are quite illiterate you know."

"Have you ever been to the South, Ahmed?"

"Oh, never, sir. That is a very backward area of our country. Our government is trying to improve conditions there . . . to eliminate its illiteracy and ignorance."

Ahmed had said nothing indicating that he regarded the southerners of his country as a different race of people.

My obvious interest prompted Ahmed to volunteer to take me to meet some of the men he knows who worked in the Ministry of Education. I was delighted.

"We shall do that at the very first opportunity. And I shall also have you come to my home to meet my wife and our little son before you leave."

I thanked him and told him I would be most pleased to come. We eased to a stop in front of the Khartoum Cultural Center.

The Women's Bazaar proved to be a colorful affair, with its attractive display of fabrics and fine needlework. Moreover, it was a showplace for the attractive female exhibitors, ranging in age from pigtailed preteens attired in blouses, skirts, and socks to the mature women in their loveliest white and pastel outfits. Having removed their veils, the latter revealed the variety of their black and brown, rounded and chiseled good looks.

Looking at these women reminded me of how far their society has moved from the days when veils were the forbidding symbols of their unhappy status under the strictures of the ancient Muslim code. In the old days women neither voted nor held property. But with enlightenment and the reforms that accompanied it, changes began to come, replacing the old repressive order. Today's women of the

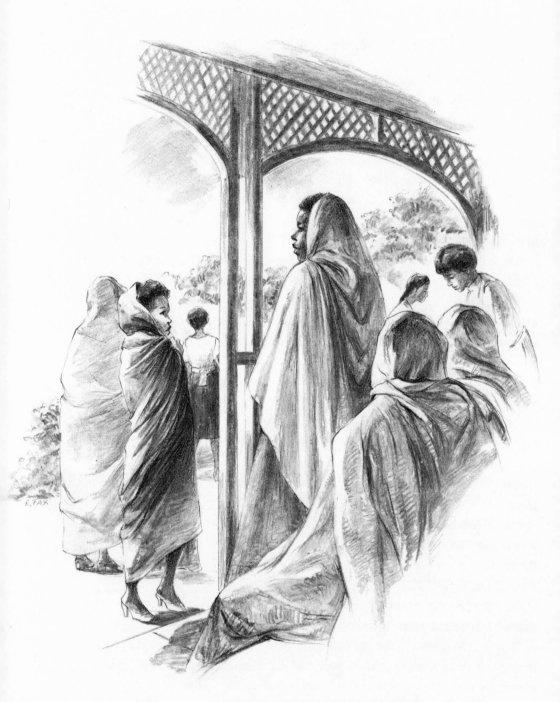

AT THE WOMEN'S BAZAAR, KHARTOUM

Northern Sudan do wear the veil on the public streets. But they vote. Moreover they hold public office and those whose talents are so acknowledged enjoy the respect that was denied their mothers and grandmothers. For more than an hour I reviewed the exhibits and sketched before Ahmed reappeared to reclaim me.

A little later that day I met a graying, distinguished-looking black officer of the United States Embassy. A pleasant Midwesterner, he invited me to his home to meet a few other black Americans stationed in Khartoum. Together they summarized briefly what was happening in the Sudan.

The military government had suspended the existing constitution and Parliament, and had banned all political parties. Bitter feuding and fighting raged with such ferocity in the south it was considered dangerous to travel there. For that reason my own appearance had to be restricted to Khartoum. The grimness of the situation eased, however, as we laughed uproariously over the Arab-Negro concept as expressed to me earlier by the obviously uneasy American embassy officer. *When*, we wondered aloud, will that Yankee-Doodle-Dandy, moon-exploring, supersalesman-of-materialism-white man-boss EVER get his head straight on this color thing?

But now, how about that white embassy officer who had interviewed me? How really ignorant was he about Arab-Negro relations in the Sudan? Isn't it a bit naïve to assume that men such as he are constantly stumbling over their own diplomatic feet? In retrospect I detect something in their attitudes and conduct that is just as closely related to American interests as to their personal prejudices. And what becomes clearer and clearer is that, his built-in convictions of white superiority notwithstanding, the American foreign service officer's posture toward race and color overseas varies according to what is at stake for America. Two classic examples come immediately to mind.

Take Liberia. For the past one and a quarter centuries the Afro-

American refugees from slavery who settled the nation have treated Liberia's indigenous people badly, and with little or no official opposition from the United States government. Liberia's political leadership has been in Americo-Liberian hands. Not one of its eighteen presidents, from Joseph Jenkins Roberts to William R. Tolbert, has come from any of Liberia's tribes. And under most of them, human slavery, corruption in government, and forced labor on the Island of Fernando Po were commonplace. As American authorities looked the other way, American business interests, principally the Firestone Rubber Company and Republic Steel, grew richer and richer in Liberia.

On the other side of the coin, the independence, nationalism, and Pan-Africanism of the late Kwame Nkrumah of Ghana were not favorably regarded by our government. Nkrumah was considered "too far to the political left." The political corruption in Liberia and the lavish spending by her presidents for their own comforts were passed over lightly here. The same things occurring under Nkrumah were held before the American people as prime examples of the kind of bad conduct that was "holding back African progress." And even though some American investment existed in Ghana (Hershey Chocolate, for instance) it was by no means as dominant as in Liberia. So there was great rejoicing in some high American quarters when the Nkrumah regime fell.

At the time of my visit to the Sudan, I had the feeling that the Sudanese government at Khartoum was not the darling of our government and the interests it represented in Africa. Therefore the questions of who and what was good and bad—of who was a "cruel Arab" and who a "downtrodden Negro," were not wholly and inflexibly tied to the admittedly twisted American concepts of race and color.

The cool, clean, white, ground-floor studio building of the Khartoum Technical Institute offered a welcome oasis from the pressure of the heat outside. I was greeted at the entrance by the tall, handsome head of the fine arts division, Bastawi Baghdadi, who introduced me

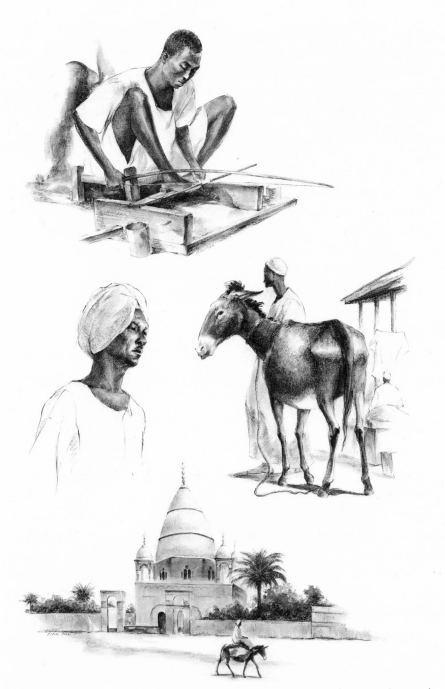

SUDANESE VIGNETTES—IVORY BEADS MAKER (TOP) AND MAHDI'S TOMB (BELOW)

to his staff of five men. None of the latter appeared to be over thirty-five. They led me into a room, empty except for a few worktables and stools, and ordered cool, soft drinks. I was asked to take the only chair in the center of the room. Then each took a stool from beneath the tables and formed a semicircle before me. Though polite they were noningratiating and noncommittal. I instantly had the feeling they *wanted* to communicate with me. But because they had dealt previously (and perhaps not as meaningfully as they had wished) with the white American cultural representatives in Khartoum, they felt it wise to maintain their reserve. Was I merely a black "honorary white American" with nothing to share with them but the color of my skin? They were, I thought, about to test my sincerity.

"Is there a Negro Art in America, and if there is, what is the reason for its existence?"

"Would you kindly define more explicitly, what you mean when you say 'a Negro Art'?" I replied.

"I mean an art that has a very special reason for being created by the black artist of America."

"Yes, we do indeed produce in America an art that one may call 'Negro Art,' and it appears in several media and in several forms. Perhaps the most widely seen and heard are in the performing arts—music and the theater—where the performances are often challenging, accusing, angry. There one hears the instrumentals of, say, Miles Davis, Charley Mingus, John Coltrane, and the vocals of Ray Charles, Lou Rawls, B.B. King, the late Billie Holiday, and Aretha Franklin. You may find it in the poetry of LeRoi Jones, Margaret Walker, Claude McKay, and Langston Hughes. It is in the prose of Richard Wright, Sara Wright, Paule Marshall, James Baldwin, Eldridge Cleaver, and John O. Killens."

My hosts were all attention as I continued. "And it is the graphics of Charles White, John Wilson, and Ollie Harrington. It pervades the canvasses of Jacob Lawrence, Benny Andrews, and Romare

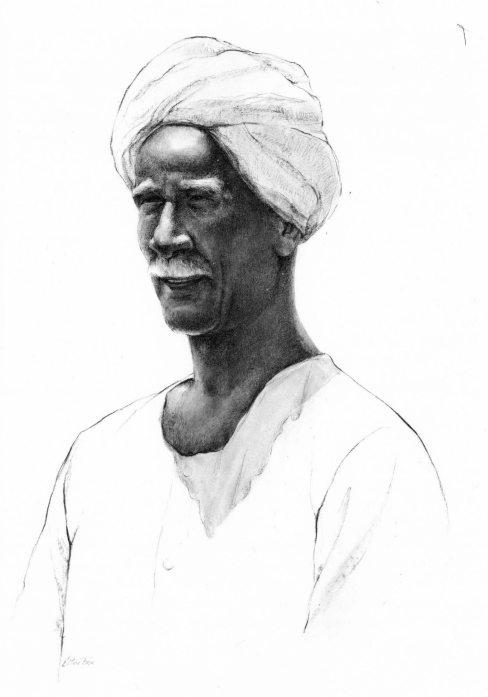

ABDUL—THE MARKET VENDOR

Bearden. And it appears in the sculpture of Betty Catlett Mora and Richard Hunt. Their art exists because some among us feel the need to say to the world, 'Look! This is what it is like to be black in America.' The recent visit to America of your own sensitive painter, Ibrahim el Salahi, afforded him a first-hand view of the art I have just described."

I was asked if being black has had any special bearing upon what I am and what I produce. "It could not possibly be otherwise with me," I responded. Other questions revealed their knowledge of the Harmon Foundation, a white philanthropic New York based group that had been instrumental in bringing the work of black American artists to public attention for the first time in the 1920s.

They asked me to describe the Muslim movement in the black communities of America and the relations between black Americans and Jewish Americans. They were especially anxious to hear about black protests against American discrimination based upon color. For fully an hour these men, whom I had been led to believe held no interest whatever in discussing black-white relations in our country, queried me. Then obviously satisfied that I had been honest with them, they thanked me warmly and proceeded to show me through the departments of their art school.

Though I had grown curious as to just what incident or incidents had generated their initial distant reserve, I studiously refrained from mentioning my awareness of it. If it was important, I reasoned, it would be revealed to me. Sure enough, an incident that took place on the following evening provided a telling clue.

We were dinner guests—a member of the embassy staff, another American, and I—at the home of a department head at the Khartoum Technical Institute. Present with us was the same group that had welcomed me on the previous day at the art department. During the evening one of the latter young men asked the embassy officer if he would amplify upon, and possibly clarify, some obscure question about black-white relations in America.

The question was so commonplace I cannot accurately recall it. I do recall feeling that it merited an answer, for whenever I had been asked a similar question I tried to provide a direct reply. Our embassy man saw it differently, however. Maybe it was the influence of the martinis. At any rate his curt reply reminded the young teacher that the Sudan had problems of its own it had not solved. And with that he closed the conversation. A momentary chill descended upon the party.

Within fifteen minutes our embassy man suggested to me that I might want to be leaving. I politely declined. Besides feeling that my sudden departure would be insulting to our hosts, I was having a good time. Our alert host quickly interjected that if the officer had to leave, he (the host), would see that I arrived home. Three hours and many toasts and hearty laughs later, I was delivered to my hotel. Not a single word had been said about the earlier interruption, and the evening had gone splendidly. Our host had been most adroit.

Ahmed Omar kept his word in seeing to it that I visited the Ministry of Education and that I had tea with him at his home. During my visit to the former I was shown through the publications division by an editor and the art director. We passed several young women, veils cast aside, typing manuscripts in Arabic. In an adjoining room we looked over the stacks of paperback publications resembling pocket-size comics. They were illustrated fables with Arabic texts, and according to my hosts, they were being prepared especially for young readers of the Southern Sudan.

"These are a part of our program of mass education for that section of our country. We want them to learn Arabic along with English. Arabic is, after all, the language of many of our faith. We hope soon to be one undivided people." The slim young editor expressed his hope with a firm and quiet fervor as he waved his hand over the stacks of booklets. His seriousness was unforgettable.

In the cool garden of his modest home, Ahmed introduced his gracious Egyptian wife and their seven-year-old son. Following the tradition of her faith, the wife retired to her quarters, leaving us alone

to converse after serving our refreshment. Only when I was about to leave did she reappear to pay her final hostess's respects. She was a beautiful woman, tall and regal, with golden brown skin and black wavy hair accented by heavy gold bracelets and earrings. Her only makeup consisted of a purple dye decorating her small sandaled feet and the palms of dainty hands.

Though I was constantly meeting a number of Sudanese, there were two things I wanted very much to know. The first I felt I could ask my artist colleagues at the Technical Institute. "Please tell me something. Do you of the north designate yourselves as 'Arabs' and your fellow Sudanese to the south as 'Negroes'?"

The question evoked smiles and knowing glances. "We call ourselves Sudanese—*Northern* Sudanese. Our brothers to the south, they are Sudanese too—*Southern* Sudanese. And *you* my friend"—here the speaker began to grin—"You are an *American* Sudanese."

I found an unexpected opportunity to ask the second question the afternoon I was introduced to the Honorable Mohammed Y. Mudawie, judge of the Sudanese High Court. We had been brought together by my lifelong friend and fellow Baltimorean, Donald Wyatt, who was in Khartoum on business for the African-American Institute. A portly, urbane, jet black man who had spent considerable time in New York City, the jurist quickly let me know how well he remembered Harlem.

Now anyone who knows Harlem from the inside out is well aware that its highly publicized crime, slum buildings, overcrowded schools, rats, and filth are not all there is to it. The famed Arthur A. Schomburg Collection of the New York Public Library is there, and it is used by scholars from all parts of the world. Harlem Hospital with its international staff is just a few yards distant, and the high-rise luxury apartment complexes—Lenox Terrace, Morningside Gardens, Esplanade Gardens, and Delano Village—are within a half-mile radius.

Many distinguished Afro-Americans live in Harlem. Historian John

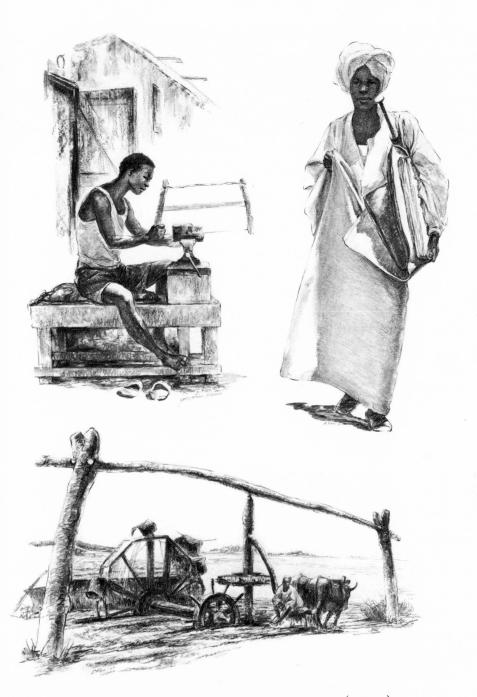

MORE SUDANESE VIGNETTES WITH AGE-OLD SAKIEH (BELOW)

Henrik Clarke, painter Charles Alston, writer George S. Schuyler, book collector Clarence Holte, curator Jean Hutson, and Dr. Calvin Sinnette are among them. That their names are unfamiliar to most white Americans only shows how little white America knows about the place and its people. Harlem and eminent Harlemites are known, however, to many blacks outside the United States. Moreover, the Harlem celebrities are surrounded by scores of professionals and semiprofessionals who live quietly and comfortably in the area.

If you have ever walked along 125th Street from the Apollo Theatre to Lenox Avenue, you have passed the National Memorial African Book Store owned and operated by Louis Michaux. If you walked those two blocks during the warm summer months you saw and *heard* the street orators, either in front of Michaux's book shop or in front of the Hotel Theresa. Ranging from spokesmen for various Islamic sects all the way to extreme black nationalism and various stages of socialism, the most theatrical of the speakers always draw crowds. Their speaking area, known as "Harlem Square," will soon be dominated by the high-rise New York State office building nearing completion.

Still, the location is thoroughly familiar to black residents and to black visitors from other states and countries. Black Americans visiting either in the Caribbean or in Africa will frequently be asked by local residents who have been to Harlem, "How are things up at Harlem Square, brother?" And since the community is also quite familiar to those blacks abroad who frequently have blood relatives living in Harlem, Judge Mudawie's first question came as no surprise. "Tell me, what is happening these days out on Harlem Square?"

The judge, attired in the neat business suit he likes to wear, certainly would appear as a quite normal fixture on the corner of Seventh Avenue and 125th Street. Indeed, he grew expansive as he recalled his experiences there.

"I used to stand in the crowds gathered around the street-corner speakers in front of Louis Michaux' bookstore. Everyone assumed I

was just another local resident eavesdropper . . ." He laughed.

I asked Judge Mudawie if he, a lifelong Muslim, regarded those of the black American community with seriousness.

This is what he told me. "When a man declares he is a Muslim we do not challenge his faith. For our faith teaches us to assume that such a man believes Allah to be God and that Mohammed is a prophet of Allah. When a Muslim violates Islamic law he is subject to punishment by Allah. But we do not presume to expel him from our faith for his transgression."

One is inclined to listen carefully to a man who by training and profession is not given to making loose pronouncements.

Khartoum is a curious and delightfully pictorial blending of the old and the new. As I walked along the banks of the Blue Nile, I heard the creaking and groaning of the ancient ox-powered irrigation device, the sakieh. Persistent though it was, the sakieh was losing the battle of noise to the air horns of swiftly passing cars. The bridge off to the right spanning the Blue Nile had borne the weight of countless men, beasts, and carriers of all descriptions. Only that morning early motorists had been obliged to creep across that span behind a camel caravan en route to Omdurman.

There at Omdurman the Blue Nile and the White Nile meet. In years past it was a fishing village. Boatmen plied its surrounding waters until the aforementioned Mahdi won his victory in Khartoum and established his capital at Omdurman. That city rapidly became an African community and existed as such until Kitchener's forces overcame the khalifa in 1898.

Today the Mahdi's tomb, the home of the khalifa, and an occasional shadoof along the riverbank are the lone remaining reminders of the city's historic past. But as I walked through the open market, swarming with its scores of white-clad black people, I had the feeling that much of the past is still there in that legendary city of two hundred forty thousand.

Back in Khartoum, painter Ibrahim el Salahi and I sat over dinner at his apartment and talked of the present. The phonograph record, a carefully selected memento of Ibrahim's visit to the Harlems of America, turned slowly on the stereo as the tortured, muted trumpet of Miles Davis filled the room with black music.

My bearded host closed his eyes momentarily as he spoke. "This music reaches deep inside me. He is one of my favorite artists. And why not? He is one of our brothers and he plays the music of black people everywhere."

I recalled that thought as Ibrahim and his fellow Sudanese artists handed me a gift. Still not fully dry and pungent with the smell of oil paint, the package contained two silk-screened wall hangings taken from rubbings from the Sudanese walls of antiquity.

The words of the donors were brief and simple. "Your sincerity has gone straight to the hearts of the Sudanese people."

I was especially warmed by their tribute. These were the same men who had skeptically gathered before me in a polite and formal semicircle on the first day of our meeting.

3
ETHIOPIA

No place that I saw in East Africa intrigued the eye and distressed the spirit as much as Ethiopia. What might have been the incomparable beauty of land and people had been marred by the erosion of the former and the deprivation of the latter. And nowhere in that venerable kingdom were both more noticeable than in the mountainous areas of the northwest. I know. Within my first forty-eight hours in Ethiopia I had journeyed along mountain roadways through four hundred miles of it.

My initial view of the former Italian colony of Eritrea and the province of Tigre took me on a round trip between Asmara and Makale. Asmara's orderly cleanliness contrasted sharply with what I found in the small towns and villages just beyond. There, knots of hungry, begging adults and children swarmed about our station wagon at every gasoline stop. Some were blind and horribly deformed. As they closed in upon us they seemed oblivious to the rapacious flies clustered about their open sores. Soiled, empty hands and parts of hands clawed the dusty air as the beggars, some on homemade crutches, hobbled about whining for coins.

At one point as we stopped to eat our sandwiches a group of ragged children emerged like apparitions from what we had assumed to be a barren wilderness. They said nothing. They didn't need to. Unnatu-

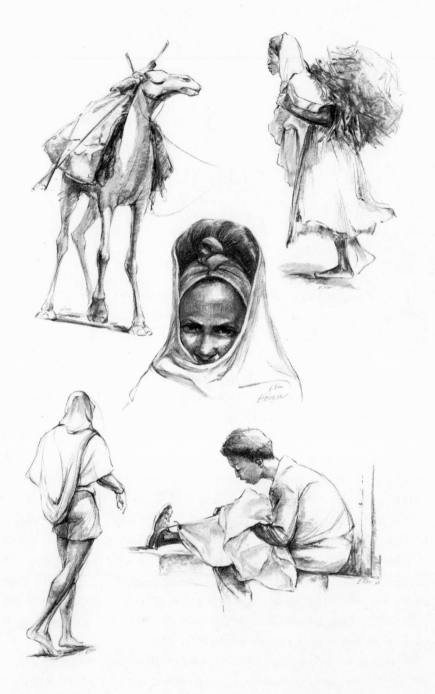

ETHIOPIAN VIGNETTES—GALLA WOMAN (TOP RIGHT) AND BOY TAILOR (BELOW)

rally bright and deeply recessed eyes shrieked their hunger. The sandwich I was eating suddenly grew tasteless. I shifted my gaze uneasily to the backdrop against which those children had mutely fixed themselves.

What I saw was an eerie combination of treeless, ashy canyons, plateaus, and buttes. Soil erosion and wind had exposed massive rocks, giving the area the look of a battleground of giants whose great stone missiles had been left where they fell. Off on a distant hill the stillness of the tableau was broken by drifting trails of gray dust raised by herdsmen leading cattle, sheep, and goats in search of fresh, moist feeding grounds. It was bleak and sterile and forbidding. And it was my unforgettable first impression of the hereditary African monarchy of which I had heard so much. None of what I had heard bore the slightest resemblance to what I was looking at.

Ethiopia's four hundred thousand square miles cover territory roughly the size of Texas, Oklahoma, and Kansas combined. Of its twenty-three million inhabitants six hundred forty-four thousand live in Addis Ababa, the national capital. Asmara, the country's second largest city, has a population of one hundred seventy-eight thousand. Ethiopia's neighbors are the Sudan to the north and the west, Kenya to the south, and the French Territory of the Afars and Issas (former French Somaliland) to the east.

Much of Ethiopia, particularly the west, is plateau, whose moderate temperatures, so typical of Asmara and Addis Ababa, offer a sharp contrast to the country's torrid lowlands. Rainfall, abundant in many areas, occurs with the February to April "little rains" and the "big rains" coming between July and mid-September.

Anthropologists commonly refer to Ethiopia's people as Cushites (a Hamitic language group) and Amhara, (a Semitic language group). They then suggest in rather vague phraseology that the two groups managed to get themselves mixed up with "a Negro element which possibly appeared as early as the eighth millennium B.C." They fur-

ther point out that more than forty tribes are represented in Ethiopia, of whom the Amhara, the Galla, the Somalis, and the Tigreans are the most important.

Such anthropological findings may or may not be wholly accurate. As a layman I am not qualified to dispute or affirm their scientific conclusions. But as a person trained to observe, I found the hundreds of Ethiopians with whom I came in contact to be a people of obviously mixed lineage. Indeed, Ethiopian history, which I shall sketch ever so briefly, indicates how such mixtures came about. It should be no surprise, therefore, to find as I did that Ethiopians bear a striking resemblance to Afro-Americans who, with ethnic roots in Africa, are also a people of various Indian and European bloodlines.

A most amusing incident at one of the schools proved how true that is. It occurred in Nazareth, quite close to Addis Ababa, where I had just addressed a bilingual audience in English. Two young black men approached me. They were speaking to each other in the native Amharic, which I do not understand. "Hello! Which village are you from?" I asked. The shorter one smiled and replied in Ethiopian-accented English that he was a native of Nazareth. The other grinned and grasped my hand. "Man, I'm from Griffin, Georgia. My name is Haskell Ward and I'm here with the Peace Corps!"

Christianity has roots in Ethiopia that are both deep and long. It is estimated that nearly half the population are affiliated with the Ethiopian Orthodox Church and that they generally inhabit the highlands. The large Muslim group, along with those of pagan faiths and a Judean sect, comprise the remainder. Many of them occupy the lowlands. I have already mentioned that this is a land and a people of great age. Ancient Ethiopia is frequently referred to in the Old Testament of the Holy Bible as well as in the writings of Herodotus and Homer.

The famed Aksum kingdom is believed to have been formed at about the fifth century B.C. Christianity came to Ethiopia in the mid-

dle of the fourth century A.D. with the arrival of Saint Fromentius, a Syrian maritime prisoner.

Within the next three centuries the Aksum kingdom began to decline, what with the swiftly expanding Arab empire and the rise of Islam. And during the numerous wars between Christian Ethiopia and her Muslim neighbors, many Ethiopian pagans were converted to Islam. But as the battles began to exhaust both sides, Galla invaders from the south took full advantage of Ethiopia's vulnerability, necessitating the moving of the heart of the Ethiopic kingdom farther north to Gondar.

There followed a period of feudal decay that came to be known in Ethiopia as "The Age of the kings of Gondar." But since no condition among men ever becomes permanently static, a transformation began to occur with the ascension to the Ethiopian throne of Theodore II in 1855. Theodore's cruel and unrelenting repression of British envoys, coupled with opposing Egyptian and internal foes, both real and imagined, soon brought a British expeditionary force to Ethiopia. In the ensuing struggle Theodore took his own life.

Modern Ethiopia's emperors, beginning with Menelik II, who was crowned in 1889, have restored the Solomonic dynasty to the throne. Certainly the most enduring of them is Ras Tafari Makonnen, who has taken the throne name, Haile Selassie, meaning "The Power of the Trinity."

The cousin of Empress Zauditu, Selassie succeeded her to the throne in 1930. Five years later Italy, after forty years of trying, finally met success as Ethiopia's invading colonizer. It was the northern section of the country through which Mussolini's forces swept, and it was there that I had my first glimpse of the kingdom of "The Conquering Lion of Judah." I was not to see Addis Ababa until later.

My immediate contact in Asmara was a white man I shall call simply, "Browne." Although not fat, there was a comfortable middle-age fleshiness about Mr. Browne that was inconsistent with his ten-

dency toward a driving nervousness. I soon learned that he was a Midwesterner who had done some journalistic writing. He was a sincerely motivated man of the you-do-it-strictly-by-the-book school. While one could question the astuteness of his judgments, one could never question Browne's unflagging patriotism and his devotion to duty as he saw it. I quickly knew that I could never love either the man or the unimaginative tenets to which he clung so fiercely. But I readily admit that his foot-slogging, never-say-die approach to his job held a strange fascination for me.

Browne and I disagreed openly. Oh, yes! And when his Scotch-Irish temper got the better of him, he soon discovered that I was no shrinking violet myself. The morning following the day of our meeting, Browne and I left the sun-drenched pleasantness of Asmara for Makale, two hundred miles south. Browne did the driving, and he had planned a brief stopover in the village of Adigrat. That trip, as I indicated at the beginning of this chapter, was unforgettable. The drive of one hundred and thirty miles through the mountains made me uncomfortably aware of a dry barrenness all around. I momentarily forgot it, however, when we arrived at Adigrat. There we proceed immediately to an elementary school where, standing outdoors, I sketched for two hundred and fifty eager and appreciative boys and girls.

Adigrat was poor enough. I had lived in the home of poor black relatives in rural South Carolina, as well as among my impoverished neighbors in a small Mexican city. And I thought I had seen the worst in rural Bolivia, high up on the Andean Altiplano. But that seventy-mile trip between Adigrat and Makale outdid them all. And the squalor was all the more noticeable in view of the order and cleanliness back in Asmara, a city that had been made attractive, ironically enough, by the former Italian invaders.

At the secondary school in Makale, we met several young black and white Americans with the Peace Corps. Much that is negative has

BEGGAR

been said and written about this overseas contingent. Some of it has emanated from the political right, who would never find anything good to say either about it or its early director, Sargent Shriver. Still other criticism has been echoed and reechoed by factions of the left, quite willing to repeat charges made by some Peace Corps hosts that the group sought to subvert their countries. There in that poor and wretched province of Tigre two things seemed certain to me. If any critic of the Peace Corps thought the young people I saw in Makale were on a pleasant safari, they were grossly mistaken. And if the filth and poverty of the area had not already subverted its inhabitants, there was little any Peace Corpsman could hope to do.

Wendell Brooks, a young black graduate of California's, Whittier College, was one of several black and white corpsmen who were the first to come to Ethiopia. Wendell was a thoroughly alive and vibrant man. He invited me to his home for dinner, where I found him and a young Ethiopian student mopping the floor together. Brooks had put a small amount of kerosene in the water as a disinfectant—a simple lesson in hygiene that I am sure was not lost on his local companion. Another young black man there, whose name escapes me now, had fattened the hog upon which we later dined so sumptuously. He was an agriculturist—a quiet chap who had been graduated from the Agricultural and Technical College at Greensboro, North Carolina. I having taught there myself one summer many years ago, we chatted together about the changes that had recently transpired in the town and at the school.

Before Wendell served dinner Jerry Hoffman, a pensive young white fellow, and an attractive white girl walked us outside to a nearby open clearing. There they looked over a few calves preparatory to making a purchase. They reminded us that the the period of Coptic fasting was nearing and they did not want to risk being without meat. Who would butcher the animal? That was no problem. There were several local butchers and one of them could be easily engaged.

We returned to the house where Wendell had an excellent meal awaiting. Following dinner much wine was drunk and Wendell, an excellent instrumentalist and singer, produced his guitar and led the singing of American folk songs. We sang together, a mixed group of Ethiopians and Americans, until fairly late, before I retired to my hotel. We would have to be on the road again by six in the morning. What I had seen of the Peace Corps there pleased me greatly.

Mr. Browne negotiated the serpentine mountain roads with the expertness born of constant practice. A humorless and apprehensive man, he centered his conversation upon the grim specter of the Shifta, a notorious band of politically motivated thugs who roamed the mountains. Browne made it clear in terms both graphic and frightening that the bandits were especially given to prowling early in the morning at the very time and in the very area where we happened to be.

He elaborated. "They strike suddenly and if you show any tendency to resist, they kill. But if you give up your clothing and other valuables you'll be allowed to drive on unhurt."

Now no one wants to be murdered by highwaymen, but it does deflate one's ego to contemplate the alternative of driving back through the mountains and into the city stark naked. It was doubtless that prospect that caused Browne nearly to miss a curve when I announced that I thought I had detected a movement in the forbidding and lonely hills just above us. Whatever I saw, or thought I saw, apparently was harmless, for we made it back to the city without incident.

Twenty-four hours later Mr. Browne and I were three hundred air miles away in the historic, fly-infested city of Gondar. There I was scheduled to lecture at the Public Health College. Browne was edgy. He had been quite attentive to what I had been saying to students and here in Gondar he decided to let me know what he liked and did not like about my presentation. To that end he insisted, over my protestations, that I read his confidential evaluation, which he had

ETHIOPIAN BAOBAB TREE (NAZARETH)

prepared with characteristic sincerity and seriousness.

The report was glowing in its praise of my delivery and my rapport with audiences. It was not enthusiastic, however, about the uncompromising candor with which I discussed the question of racism in America. Browne thought I had been coming down too hard on white folks. I felt his report was accurate and was willing to let the matter stand there. Browne, however, wanted me to "tone down" my remarks that, in his judgment, placed America in an unfavorable light. I flatly refused, and we argued.

For a few moments we shouted at each other, a reaction I'm sure we both later realized was quite as foolish and futile as it had been normal. Thinking about it alone later that night, I realized that Mr. Browne's experiences in his previously all-white world had not prepared him to apprehend the depth of my feeling in this matter.

Certainly my experiences that extended throughout my black world and into a limited portion of his would not allow me to express myself on American racism in terms he would find soothing. Then I thought again about his report. How ironic that this conscientious man could praise my swift rapport with Ethiopians while we two Americans, after three hundred and fifty years, could find so little rapport between us. It was far more than those brief verbal fireworks that separated us. Friends disagree bitterly and are still friends. But here between this man and me existed a gulf that neither of us could ever hope to bridge.

Sadly enough I still harbor the feeling that Mr. Browne would find it considerably harder than I do to know that the gulf separating us was by no means created by color differences alone.

I was fully and painfully aware of this, and a bit apprehensive too, as I headed south for Abbis Ababa. While I could handle myself ably enough, I honestly did not want any other such confrontations—not immediately, at least. They were distracting in that they diverted energy away from the real objectives of the tour.

Addis Ababa, Ethiopia's capital, was founded by King Menelik II in 1886. The site was then known as Phinphinnie. After several other locations had been tried, Phinphinnie was settled upon because of its central position and abundant water supply. It was then given its new name, Addis Ababa. In the Amharic tongue that means "New Flower." This plateau city of six hundred forty-five thousand rises eight thousand feet above sea level, and its height blesses it with a pleasant climate. When I was there in the spring of the year I found the days warm but never oppressively hot. Nights were invariably cool and often chilly, and I also found the city to be a fascinating blend of old and new.

Modern buildings with still others under construction, paved thoroughfares, and motor traffic provided a twentieth-century backdrop for the quaint. Burros laden with burdens of many descriptions, including elderly men, passed beneath the high-rise office buildings. Men in jodhpurs and women wearing shammas, those filmy white cottons typical of Ethiopia, paused before shop windows and streamed in and out of stores.

At one point a small contingent of smartly uniformed military equestrians steered their sleek horses carefully past an area of the street where building construction was in progress. Small groups of bus riders waited, meanwhile, for their vehicles in the shade of modernly designed canopies. And stately palms lining the avenue's dividing island spread their graceful leaves beneath a beneficent sun, warming but never sweltering the terraced city. That was the pleasant face of Addis.

The other face was not far away. I saw it in the side streets off the main avenue—streets that were not paved but narrow, and crooked, and mean. The low buildings flanking them were old and ramshackle, and their inhabitants obviously not of the city's elite.

The cramped quarters they shared bore grim testimony to their struggle for survival. Children swarmed throughout the area. I saw

EXPECTANT MOTHER—ADDIS ABABA

women, old and young, trudging the uneven roadways, their backs bent beneath the weight of huge jugs of water. It was their only means of "piping" the precious fluid into their meager homes. Other young and stunningly attractive girls, their eyes ever alert, stood by with apparently nothing to do. I learned later that their profession was quite as old as their legendary land.

Woman's place, even in the modern city of Addis Ababa, was one that did not satisfy every woman. On my first night in the capital city I heard a spirited debate between two young women and two young men. Their subject? "Free Choice or Prearranged Marriages. Which Is Better?" The affair treating a subject that was a burning question in the consciousness of young women was formally called and well attended at one of the city's medium-sized and modernly designed auditoriums. The women, traditionally accustomed to having their mates selected by parents, argued for free choice. Though I felt their's was the more solid argument, the decision of the moderator, a Jamaican, was as diplomatic as the gentleman was charming. He called it a draw.

The citizens of Addis Ababa, like their big-city counterparts elsewhere in the world, seemed more blasé than were the folk of the smaller northern communities I had seen. Their exposure to gimmicks and to foreign visitors from all areas of the globe was constant, and they learned to be critical and discriminating. Moreover, there was a group of restive students and intellectuals who not only opposed Emperor Selassie's policies but also were downright hostile to the American presence in their country. I shall explain why momentarily.

It was apparently with those facts in mind that American foreign service officer, William B. Davis, prepared as he did for my arrival. Mr. Davis pulled out every stop at his disposal, using the most effective promoter's stunts in the process. Handbills, posters, bumper stickers, and press notices in English and Amharic were included in his arsenal.

While his techniques, at first, struck me as being overdramatic, I came around to understanding why he used them. In addition to the aforementioned problems with the local citizenry, Davis had formidable competition from an outside source. The Soviet counterpart of the United States Information Service had established its own propaganda machine on the very same street and within less than half mile of Uncle Sam's. And the Soviets were doing one whale of a job in their own interests.

But Bill Davis, a shrewd Virginian, was no slouch. By the time I arrived in town he had succeeded, at the very least, in getting Addis Ababa residents to ask themselves, "Just who or *what* in hell is Elton Fax?" He had aroused human curiosity and there were those who were bound to come and have one look even if they went away muttering how sorry they were to have wasted their time.

Davis was a smart man whose drives and imagination were probably motivated by the desire to prove not merely his adequacy to the job but his superior skill at handling it. His early jim-crow experiences as a black youth in Virginia had taught him he would have to be twice as good as the other fellow to get half as far. So in addition to his promoter's skills, he brought also to his work a fluency in several languages (including Russian), along with a buoyant good nature. He needed everything he had. Addis was a tough spot.

The dissident students alone were a challenge. Those ideological differences they had (and still have as of this writing) with their emperor were profound and seemingly irreconcilable. They were by no means in accord with the concept of a feudal monarchy in this day and they wanted to rebel openly against it. But remembering the swift and ruthless punishment handed those who rebelled in 1959, they were reluctant to risk their lives against the emperor's vengeance. So they and their consorts went underground. There, even undercover, they could never be sure of their safety.

The frustration of the dissidents drove them to seek and quickly

find an object they could openly attack without risking life and limb. That object was (and is) the United States of America.

Ethiopian intellectuals have for a number of years looked askance at the American military presence in the form of air bases and installations on their country's soil. They know that such forces are there because their emperor and the United States government have agreed to have them there. To those Ethiopian dissidents there is a direct line connecting a major foreign power to the aging monarch who dares them to speak out against him and his repressive policies. For several years many Ethiopian intellectuals have lost no love on Uncle Sam. In the sophisticated city of Addis such feelings have not been hard to detect.

It did not take me long to sense what was happening. American speakers presented by the U.S.I.S. were particular targets of student wrath and scorn. I knew that as an American speaker, who was also black, I would be on the hot spot in certain situations. But exposing myself to public ridicule *that* far away from home was not what I intended to do.

During my stay in Addis Ababa I was called upon to give several interviews as well as to sketch and speak in numerous schools. I cannot recall a single instance when I spoke that I was not questioned about violations of the rights of black people in America. And although my insistence upon reporting honestly on that issue disturbed some embassy folk, I was enthusiastically supported by Glenn Smith, chief of the U.S.I.S. in Ethiopia, and by Bill Davis. Smith, incidentally, is white.

That honesty and integrity transcend race was again demonstrated to me in Jimma. Located three hundred kilometers southwest of Addis, Jimma, a city of thirty thousand, is Ethiopia's largest wild-coffee-growing area. Upon arriving there I immediately sought living accommodations at the Hotel Gihon. One look at the small lobby fairly bursting with American soldiers (sent to Jimma, I was in-

formed, to train Ethiopian troops) sent me scurrying for something quieter. I found it at the little Hotel Ras Mesfin. There I also chanced to meet a young white American waiting to meet a friend. He was James N. Elliott.

A native Oklahoman, Elliott was in Jimma as a teacher in the local agricultural school established by Oklahoma State University. He wanted to know what I was doing there. I told him.

"What do you tell the students when they ask you about United States race relations?" he inquired.

"I tell them the truth as I know it."

"The truth as you know it isn't always pleasant is it?"

I nodded. Elliott's response was a mild shocker. "Good God, man, you're just what I've been hoping to find! Would you, *could* you spare some time to come talk to my boys? Though as a Southerner who lived fairly close to black people I've come to learn how little I really know. I've been completely stumped by questions put to me here that I can't answer. It'll mean more than you'll ever know if you'll take a little time to set the record straight."

Jim Elliott was deadly earnest. I found an irresistible freshness in the uncluttered honesty of this young white Southerner. Needless to say I did indeed meet with his students. Later at his home there in Jimma I joined his wife, Patty, and their children at an excellently cooked southern meal. And we *talked*. It had been some time since I had communicated so freely and so meaningfully with a white fellow American. And it was a heartwarming experience.

Verbal exchanges were not always possible, however, and where they weren't I leaned heavily upon the visual. When not sketching for others I was taking note of what their presence alone said to me. Ethiopia abounded with little picture stories.

There was the day in Nazareth, just one hundred kilometers south of Addis, that I saw the wiry Galla women with their distinctive coiffeurs. How they managed to get along the roads so swiftly, as they

MORE ETHIOPIAN VIGNETTES FROM JIMMA AND GONDAR

bent under heavy back loads, I do not know. They as well as the white-robed Muslim astride a horse seemed quite oblivious to everything other than what they were about. A pair of chocolate brown women, their sheer white cotton shammas billowing behind them, crossed the road just ahead of a flat-bed truck groaning beneath the weight of hardwood logs. Not once did the women look behind them. Beggars whined piteous laments. And flies, FLIES, FLIES, swarmed everywhere.

Not far from Nazareth I found the huge, Dutch-owned, elaborately irrigated Wonji Sugar Estate employing ten thousand resident workers. The latter lived on the plantation in styles commensurate with their skills, the humblest dwellings inhabited by the least skilled. There at Wonji the cane was grown, harvested, and processed in the complex providing its own medical, recreational, and educational facilities. It struck me as being a startling example of a twentieth-century agricultural enterprise operating in feudal plantation style near the ancient setting of the wild Awash River.

East of Addis Ababa and near the Somali border is the small city of Dire Dwa. I can never forget it because of the territorial warfare between Ethiopia and Somali that was in progress at the time of my visit. Civilian flights in and out of the town were by no means a foregone conclusion. But once in Dire Dawa I found it colorful and fascinating.

Old and new Dire Dawa are separated by a river whose shallow bed, during the rainless season, becomes a dry passageway linking the city's two sections. I crossed to old Dire Dawa, where I entered the ancient shops whose keepers were so polite. I returned the smiles and hand waves of travelers standing patiently in line prior to boarding the waiting bus. And I stopped to watch three men adjust the harness of a burro hitched to a small cart.

Back across the dry river bed I reentered new Dire Dawa, where I sketched for an appreciative audience headed by the dignified gov-

ernor of the provinces. The midnight curfew abbreviated a lively gab session with a dozen Peace Corps workers, and I retired to pack for the return to Addis Ababa. There again, as elsewhere in Ethiopia, I

A VIGNETTE FROM DIRE DAWA

would continue to wage a personal battle with the relentless swarms of flies. What wonders some carefully chosen insecticides could do for that tormented land!

Six hundred spectators filled the auditorium at the University College at Addis. I had been told in advance that the American ambassador had not fared well with this group, and perhaps I should have been apprehensive. I was nowhere near as celebrated as the ambassador. But apparently the word had been circulating about town that I had been saying things to Ethiopians that they had not before heard from American speakers. So the critics came to see and hear for themselves. My approach to them, as it had been to all the others, was simple, honest, and direct.

"I have been told that you are a group of searching, inquiring, and challenging students. That, I believe, is as it should be. For you to be otherwise would say that you are not students in the truest sense. Therfore it is quite fitting that you should *not* be content to swallow eagerly everything offered you in the name of truth and educational exchange.

"I shall relate my own experiences to you as an American of African descent. In so doing I shall be telling you of the America I know. If in the course of what I have to say you find that I am being dishonest I expect you as students to challenge that dishonesty. For you to do less would reflect unfavorably upon you and upon what your University here symbolizes. I do not believe you will permit that to occur."

From that point on I related my story with equal regard for both the complimentary and the unflattering. I spoke of my early schooling.

"The schools we black children of Maryland attended were separate and quite unequal to those for white children. I learned early that in our system of education 'separate and equal' is a cruel myth. All my teachers were black. And they were dedicated men and women. They had to be, for they toiled in overcrowded, drafty, and

poorly equipped firetraps for half that which was paid white teachers. I know. Three of my mother's sisters taught in our local schools.

"Not far from the site of my grammar school a young white American attorney had been detained in 1814 aboard a British war vessel in the Chesapeake Bay. His name was Francis Scott Key. He had watched the all-night British shelling of Fort McHenry guarding the city of Baltimore. When, in the light of dawn, he saw that the American flag still flew over the fort, he was inspired to write the poem that is now our national anthem. A century later, as we black children sang the words Key had written, we knew they did not accurately apply to us. We knew we were not 'the free' and that those who oppressed us were not 'the brave'."

On the positive side, I told them about the opportunities of the North—of the mobility of the black American who could (and did) leave the more oppressive South in search of a better life in America. I related that while the North was not nearly as free of racism as it liked to think it was, I was able there to *work* my way through one of its fine eastern universities, and to be graduated with training I so desperately needed and wanted.

Before I finished speaking I was sure my listeners had grasped two ideas. The first was that one can and does obtain first-rate training in America—even when he is black and is not materially rich. The second was that with all its many faults ours is a nation where the freedom to speak honestly about ourselves is still alive, and it stands as one of our most precious human rights. Evidently those thoughts got to the assemblage, since my presentation was warmly received and with no challenges whatsoever.

The sense of small personal achievement with which I left Ethiopia was overcast by several nagging misgivings about much that I saw and felt. I summarize my feelings in the flat assertion that all is not well in the land of the "Conquering Lion of Judah." And I state my reasons for so thinking by posing the following three questions.

ETHIOPIAN STUDENT

Is a hereditary feudal monarchy, whose Senate and Chamber of Deputies still vest supreme authority in the person of an aging emperor, relative to the realities of this day? Will the restive intellectuals and their adherents remain loyal to a regime that censors the press and eliminates those who critize it? Will the people at large be content to suffer the indignity of deficiencies in health care and the degradation of begging for bread while the small ruling elite grows fat with prosperity?

I think not.

No, in spite of all the surface signs of modern advancement I saw in Addis Ababa, in the smart hotels, prestigious public edifices, and upper-crust opulence, I was not then convinced that these will smother the angry fires of the country's profound sickness. With the continued spreading of the malady, I am even less convinced now.

Before concluding this part of my narrative, I must clarify one thing. I have never believed that my success in communicating with East African students was attributable to some special charm or intelligence of mine that few others have. True, I did have certain things going for me. Among them were technical skills and a dedication to honesty. But they would have been of no value whatever without the help of those who arranged my visits. And they would have been of even less use without the hospitality of even my most critical hosts. After all, I was *their* guest.

That latter fact can scarcely be overstated. Prior to my visits to Africa I had read several accounts written by "experts" on Africa (all of them white), declaring how little Africans thought of or cared for black Americans. Invariably such reports stressed how little both had in common. My boyhood recollections told me differently.

I remember two Africans, both indigenous Liberians, who had come to America as students through the aid of Methodist missionaries. One was a regular visitor to our home. The special attraction for

him there was a rather good-looking maiden aunt of mine. The other, brought to America by the pastor of our church, Ernest Lyon (himself a former Liberian diplomat), attended our high school.

During the late 1950s I began to meet many Africans representing their newly "liberated" countries at the United Nations in New York. I later met others in Rome, and finally, in their own lands. It was not long before I came to know that Africans represent as many different personalities as any other people.

There were those of the urban elite (and I must say they were rare in my experience) who preferred to hobnob only with those of their own class in any race. Equally rare in my personal encounters, though I knew about them, were those African students brought here to America who, unlike their predecessors of the 1920s and 1930s, mingled socially with their white sponsors.

Such American whites, following the vogue of the early 1960s, joyfully opened their homes to Africans. And some white families, though not all of them, did so even as they actively discriminated against black Americans. Clever Africans, thus favored by monied whites, promptly went into their Uncle Tom acts while declaring themselves completely uninterested in any contact with black Americans. Naturally that set many of their white folks considerably at ease. It also provided certain "experts" with exactly the kind of "first hand information" they wanted to hear and rushed into print to spread.

Then there were Africans whose conduct was entirely different. I recall at least four instances of visitors to this country who, when in New York, went out of their way to find me. Banjo Solaro, a young Nigerian, was the first. A serious student of advertising and communications, he came to the United States through a grant. Banjo was as resourceful as he was personable. No sooner did he arrive in New York from Houston, Texas, than he telephoned me with this message from fellow artist John Biggers, who heads the art department at Texas Southern University.

"Brother John Biggers told me not to dare arrive in this city without calling you right away. He told me you would look out for me while I am here."

Biggers, who had spent some time in Nigeria, had met Banjo there. I greeted the young Nigerian outside the moderately priced hotel he was staying in on Riverside Drive and brought him over to my own apartment for a visit. From there we went on over to Harlem. Banjo laughed as he spoke about his official guide furnished by the United States Department of State.

"I told my guide I was tired and he could take the evening off. It was the only way I could be sure of getting to see you and the folks in Harlem. These white people think we don't have sense enough to know how to get together with our own folks. I was determined to do this because I know better than to believe their tales about how dangerous Harlem would be for me to venture into."

Ukuno, another Nigerian on whose television show I had been a guest in Enugu, called me immediately upon his arrival at Kennedy Airport. I picked him up there and drove him to Harlem, where he arranged to stay with another black American friend. Ukuno had studied communications in California and had lived in the Watts section of Los Angeles. He knew what was happening in America's black communities.

Gana M'Bow, a musician from Senegal, and I had met in Rome. When he came to New York with a delegation from his country he called me and made these two requests: "Brother Elton, I want you to take me to Birdland and to Harlem."

The former place was then a popular Broadway night spot named for jazz great Charley Parker, who was known among fellow musicians and jazz buffs as "Bird." Not only did Gana and I go to both places he had designated, but he took me to dinner with him at the residence of the Mauritanian ambassador to the United Nations, where we dined on an excellent Muslim meal.

Finally, Ibrahim el Salahi, whom I have already mentioned, told me how on his first visit to New York he had defied his guide's warning that Harlem was no place for him to go. "I simply left my downtown hotel and got on the subway headed for 125th Street. I had a great time."

With such personal experiences, I was not at all bothered by the rumors that I would not be liked or welcomed by Africans *because* I am Afro-American. My concern, as I have indicated earlier, was with communicating with Africans on their home grounds, in spite of being an Afro-American sent to them by an arm of my own government.

There was yet another thing. I knew I was limited from the moment I heard Africans speaking their native tongues, which I could not understand. It was chilling to realize that we Afro-Americans had been deliberately stripped of our African languages by the system of separating our slave forebears from their families and other tribal members. That was done to prevent the verbal communication that facilitated slave uprisings. So I faced East African students knowing that a terrible thing had been done to both of us.

My confinement to English (their "official language" passed on to them by former colonial oppressors and passed on to me by former slavemasters) served to demonstrate both to them and to me just how carefully the oppressor had organized his plan of divide and rule.

I readily acknowledge the effectiveness of the plan. How much more forceful I could have been with linguistic skills, along with my other attributes. But then I am not sure I would have been a specialist grantee in East Africa for very long. True, black men and women with a knowledge of African languages did (and do) work in Africa for Uncle Sam. But as first-string varsity personnel, they were obliged to play the game according to the rules—as long as they remained on the team.

As a free-lance grantee I wasn't even a fifth-string scrub. But I was more free than they to speak my mind on certain matters, a fact that

afforded several of them much pleasure as they quietly concurred with much that I had to say. And I quickly grasped the truth of this one thing: at no point during my tour of East Africa was my contact

AN EVERYDAY SCENE, ANYWHERE IN ETHIOPIA

with Africans or theirs with me *supposed* to be of direct benefit to black people.

To put it another way, I am certain that race-conscious white men, who are a minority in a world numerically dominated by race-conscious nonwhites, rarely if ever bring nonwhites together solely for their own good. That would be in defiance of white group preservation. Up to this point the techniques of racist whites have consistently been those of divide and rule. They have successfully maintained the practice and are not likely to change it.

My being brought together with Africans in Africa could therefore not have been done for the purpose of strengthening ties between Africans and me. It did serve, however, to demonstrate how freely a black American can speak out in Africa about his country's vices as well as her virtues. And that is a strong point for America to make in Africa or anywhere else. Ethiopians who publicly criticize their emperor at home or abroad do so at grave personal risks. So here one must chalk up a big score for Uncle Sam.

But what Ethiopians did not know that I do know is that (my freedom to speak honestly with them notwithstanding) I returned to my country still hobbled by all-too-familiar racist practices here at home. Moreover, Ethiopians and I both know that their emperor's denial of their individual rights is not noticeably protested by our government. Wherever such denials run counter to American interests, however, our government never hesitates to intervene, whether it be in Africa, Asia, or the Americas. How then, in face of such truths, could I seriously believe that my brief USIS-sponsored contact with Africans was meant to be of benefit to anyone other than my own government?

Knowing that so well, I could have no illusions about the significance of my small role in East Africa. That, perhaps more than anything else, is what prompted me, almost unconsciously, to look with special anticipation to the brief time I was to have in Tanzania.

A BAOBAB TREE OF TANGA, TANZANIA

4

TANZANIA

THE REPUBLIC of Tanzania was formed in 1964 by a merger of Tanganyika; the islands of Mafia, Zanzibar, and Pemba; and the uninhabited island of Latham. Tanzania's mainland, formerly Tanganyika, is about the size of Florida, Louisiana, and Texas combined. Her island partner, Zanzibar, is located twenty miles to the east, in the Indian Ocean. Surrounding neighbors of Tanzania are: Kenya and Uganda to the north; Rwandi, Burundi, and the Congo to the west; and Zambia, Malawi, and Mozambique, to the south. Tanzania's famed Mount Kilimanjaro is Africa's loftiest peak, rising 19,565 feet into the clouds.

That Tanganyika is one of the world's earliest habitats of man was established as recently as 1959. During that year excavators at the Olduvai Gorge in the northern part of the country unearthed a nearly complete human skull dating back a million and a quarter years. The find led to speculation among many scientists that perhaps here was where man had his beginning. It is firmly established that the coastal region of Tanganyika has been known to the outside world for nearly two thousand years. Seafarers from Persia, Arabia, and India, aided by monsoon winds, sailed their ancient vessels along the African coastline during the first century A.D.

In the eighth century Arabs began to colonize in Tanganyika, and

when the Portuguese arrived seven centuries later they found there a predominantly Muslim-Arab civilization. Though the Portuguese ruled the area for two hundred years, they neither colonized nor explored the interior, and with their decline Tanganyika again fell under Arab domination. Then came the first European explorers, looking for the source of the Nile. As has been previously mentioned, those Englishmen were Sir Richard Burton and John Speke.

Their coming paved the way for the German East Africa Company that established its protectorate over Tanganyika, Rwanda, and Burundi in 1890. Great Britain and Germany even agreed during that year upon what their respective spheres of influence in East Africa would be, as the German government took over the territory from the German East Africa Company. It then appointed its own governor and set him up in Dar es Salaam.

For twenty-seven years Germany was sitting pretty in Tanganyika. But in 1916, during World War I, Germany had the misfortune to lose the city of Dar es Salaam to British troops. Tanganyika then passed from German to British hands and remained so under a League of Nations mandate until World War II. After 1946 it became a trust territory of the United Nations.

The black surge toward self-determination was soon under way. In 1954 a schoolteacher, Julius K. Nyerere, formed his own political party (TANU), the Tanganyika African National Union. Its candidates won victories at the polls in 1958 and 1959, and Africans were admitted for the first time to the Council of Ministers. Two years later, in 1961, with the coming of autonomous rule. Mr. Nyerere became prime minister. In order to give full time to TANU, Nyerere, after six weeks, relinquished his chair to Rashidi Kawawa, his minister without portfolio. Exactly one year later Tanganyika became a republic within the commonwealth and Nyerere was elected president.

I knew that Mr. Nyerere, the newly formed republic's popular pres-

ident, had been keeping the big world powers on tenterhooks as he pleasantly but firmly refused to take sides in their ideological disputes. His was then a policy of watching and waiting and of taking from each side what he felt was best for his country. So in addition to visiting a place run by a man with such views, I also anticipated my meeting Norris Garnett.

Garnett, who has since left the United States Foreign Service, was young, black, intelligent, and quite unafraid of his job as an assistant cultural affairs officer. Even from the advance reports on him that reached me, he sounded like someone I would want to know. Moreover, I learned that he was fluent in Swahili, a Bantu language spoken throughout East Africa.

My initial impressions of Dar es Salaam, Tanzania's capital, were pleasant. A lovely seaport city of two hundred seventy-five thousand, its humid climate is made bearable by the cool breezes from the Indian Ocean. Its combination of colonial and modern buildings flanking clean, paved, tree-lined streets, alive with easy-going vehicular and pedestrian traffic, gave an air of authenticity to the meaning of the city's name. Dar es Salaam means "Haven of Welfare." The only discordant note to jar me immediately upon my arrival was the New Africa Hotel.

During my undergraduate student days I had worked as a bellhop at one of those traditional but down-at-the-heels hotels in mid-New York State. And I recall a couple of Grand hotels of Latin America that were everything but "grand." Rarely, however, have I seen anything more misleadingly named than the New Africa. But it was the best available at the moment. And considering that Dar es Salaam was then overflowing with refugees from hostile areas of southern Africa, it would have been mean of spirit to complain.

Indeed, I was glad to know that such a city as Dar was accessible to the brothers and sisters persecuted elsewhere in Africa. Still, I was completely delighted when some kind soul at the American Embassy,

without my complaining or asking, found nicer quarters for me outside the city proper at the little Queensway Hotel. Facing the Indian Ocean and surrounded by coconut palms, the Queensway became my own haven at the end of each day of hot and humid activity.

Although I saw a number of Indo-Pakistani Asians, Arabs, Africans, and those of mixed blood in Dar es Salaam, it was obvious that black people were a majority. The dominant Muslim faith was apparent in their attire, skullcaps for men and black, shroudlike, cover-all veils for women. Although the shopkeepers and artisans were Asian, as they were in Kampala, Uganda, I was not conscious of the same intensity of African-Asian friction in the Tanzanian capital. President Nyerere and his racially integrated government had obviously succeeded in establishing closer cooperation among Africans, Asians, and Europeans.

Of Tanzania's ten million inhabitants, it is estimated that the mainland population numbers ninety thousand Asians, twenty-seven thousand Arabs, and twenty-three thousand Europeans. The rest are Africans. Though the latter's tribes are numerous, their basic stock is Bantu, and their dominant religion, Islam. In Tanzania I was a bit surprised to find that both Swahili and English are the country's official languages.

Norris Garnett was all I had been told he was. He brought the kind of sensitivity to his work that enabled him to get the best and the most out of a specialist with the least amount of strain and friction. Most of all he understood that no person, particularly a creative one, can give his best when overburdened.

I was terribly worn down by the strenuous preceding weeks in four other countries. I must have looked it. Only eleven days previously, mental fatigue had caught up with me in Kenya. For several daylight hours I had lapses of memory resulting in my inability to recall the day of the week, the place I was in, or the name of the man with whom I was traveling. One good night of sleep cleared it up, but it had been an upsetting experience.

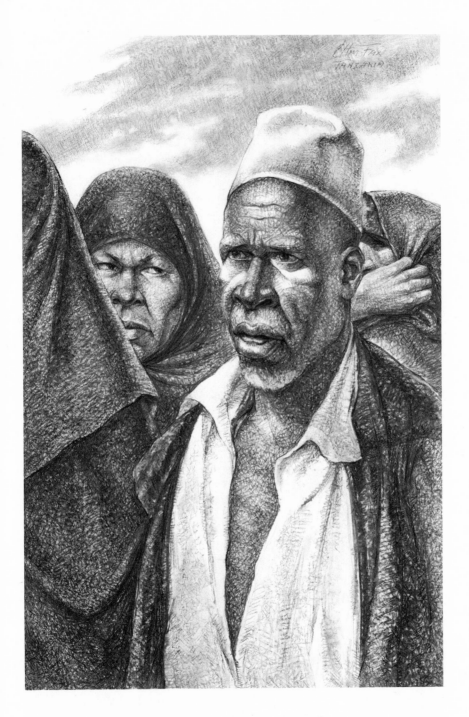

AGRICULTURAL WORKERS (TANGA)

Garnett could have pressed me further with another heavy schedule. In fact, he had already planned one. But he graciously lightened the load so I could give my best. Here was a young black man who wasn't afraid of his white bosses. He didn't feel compelled to prove his patriotism to anybody, and because I respect that kind of independence, I was ready and willing to go all the way for him. And I did.

Any question I might have entertained regarding the cooperation of majority Africans and minority Asians outside of official government circles was quickly answered for me as I began my public lectures. I found the Dar es Salaam Cultural Society a well-integrated group. Their invitation to address their members along with the local press prompted me to choose as my subject, "The Evolution of the Afro-American Artist in the United States." Attendance was full. And the press reporting on my remarks on the following day concentrated its attention upon parts of the speech emphasizing American racial injustices. The Society's reception of that talk was warmly enthusiastic, as was Norris Garnett's. On the other hand, I thoroughly understood the chill that settled on one or two others in the American embassy. They had read the papers and were disturbed by quotes in which I revealed racial trouble back in the United States.

My visits to the Aga Khan secondary schools, one for girls, the other for boys, revealed two of the best-equipped such institutions I had seen in all East Africa. Each school had been named for the wealthy and legendary Muslim leader who had built them. The Aga Khan boys' school, in particular, with its fine boarding facilities and its integrated student body, reminded me of several New England prep schools I have visited.

Its six hundred young men and their faculty provided an alert audience whose interests indicated an awareness of the world at large. Their Asian headmaster, Mr. Benrji, insisted that I spend some extra time just with members of his staff.

"Your honesty with our boys prompts us to detain you. Such an

opportunity comes so rarely to us that we seize it and hold on as long as possible."

Mr. Benrji was perhaps thinking specifically about one question asked by a student and how I responded to it. The young man had wanted to know if I felt my being black had exerted any special pressures upon me as I pursued my profession in America.

Here is what I said in reply. "Why of course my color has exerted pressures upon me that I would otherwise not have to bear. How could it possibly be otherwise in a climate charged with emotional tensions and prejudices based upon skin color? The most celebrated and successful black artists in America have, by their ready admission, been compelled to contend with major as well as minor humiliations and annoyances imposed upon them by race discrimination.

"Yet there are those paradoxical instances in which one's very blackness can open a door, as has happened to me upon one or two occasions. It is then, however, that the black artist must be on guard against the temptation to exploit a situation in which he may not be *expected* to perform up to standard. Neither moaning nor shouting invective ever succeeds in transforming mere moaners and shouters into artists simply because they are black. The alternative is to prepare oneself diligently and then to perform professionally at all times."

Though I dined at the home of one of the Asian faculty members and made a number of formal appearances in the schools of the city, I devoted the weekend to getting about among the people in the streets. My first such visit was to the huge public market. I followed that with an equally impressive journey to a farming area just outside Dar es Salaam. At the former I would see what the nation's workers had produced for their own consumption. At the latter I would see something of what they were producing for the world outside.

The market was a whirlpool of colorful humanity. Shoppers jammed the outdoor passageways, some driving small cars, others

pedaling and pushing bicycles. Most of them walked. The men wore flowing white robes or colorful wraparound skirts with jackets. A few were attired in slacks and sport shirts. All wore skullcaps and sandals.

And the women! They were stunning, what with their stately bearing and the individuality of their dress. Even the devout Muslims among them occasionally revealed the dazzling colors they wore beneath the traditional black cover-all. Their iridescent dark skins, shimmering violet and blue in the sunlight, offered a pleasing contrast to the mocha-hued Asian women shoppers with their jeweled nostrils and floating saris.

The babble of trading was all around me, as tongues alternated between Swahili, Arabic, and English. Hucksters occupying every section of the huge enclosure hawked fruits, vegetables, grains, meats, seafood, hardware, and fabrics. Of the nonedible items some were locally made while others were foreign imports.

I was particularly captivated by the seductive manner of the Arab fabric merchants, whose old-world sales techniques could easily qualify them for Academy Awards. Indeed, the allure of the market kept me busy observing, sketching, and photographing as much as I could absorb; for there was humanity, performing naturally on its own stage. The scriptless drama they enacted was, except for the roles of the pitchmen, unrehearsed and quite devoid of self-consciousness.

Just a few kilometers outside of Dar es Salaam there is a huge plantation where sisal is grown. Few types of vegetation are more dramatic than sisal, from whose fibre comes the finest natural rope in the world. Rising to heights well over ten feet, its huge clusters of stalks resemble bouquets of green bayonets thrusting their sharp points against the sky. Though Tanzanian minerals include diamonds, gold, mica, and coal, her economy is primarily agricultural and this formidable-looking plant is her number one commodity. A quarter of a million tons of its fibre were produced during the mid-1960s. I had been most thoughtfully invited by Harriet Drury, a personable white

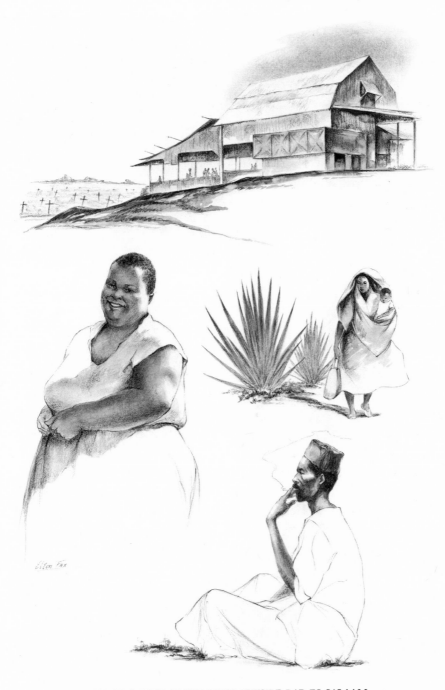

SEEN AT A SISAL PLANTATION OUTSIDE DAR ES SALAAM

American teacher in Dar, to go sightseeing with her there at the plantation on my free day.

As I walked past the vast field of the growing plant, the sound of voices drew my attention to what appeared to be a huge, half-open barn. Parked along the side of it were several large flat-bed wagons such as are drawn by tractors. Each wagon was loaded with stalks of freshly cut sisal, and workers were busy unloading and storing the

FISHERMAN'S HOME OUTSIDE DAR ES SALAAM

plant inside. They were wiry black farmhands, and the women worked along with the men. The women wore skirts, sleeveless blouses, and colorful headwraps. Each carried a metal pail. A close look at their faces revealed an occasional small gold nose ring, while broad smiles displayed rows of upper teeth filed to sharp points. They chatted excitedly in Swahili as they worked.

I looked on the other side of the huge storage barn. There for acres and acres was the precious sisal, drying and bleaching in the heat of the sun. It had been stripped and strung on low wires held in place by wooden crosses. The flaxen fibre strung out between the hundreds of supporting crosses resembled, at first glance, a graveyard covered with an eerie pale yellow pall.

Not far away was a small fishing village where nets dried out in the sun beside the houses of the local fishermen. A small boat, sails lowered, rocked hypnotically as the water lapped its sides. I gazed briefly over the calm inlet before making my way back to town.

It had been planned that I should go to Tanga, another seaport city about one hundred and thirty miles upcoast. I would speak at two schools during the day and return to Dar es Salaam that same evening. The prospect seemed interesting, and I was due for an unexpected treat in that upcoast, largely Muslim, city.

My visit to Tanga's Karimjee secondary school, an institution whose male student body was largely Asian, was made stimulating by the sharp political orientation of its young men. Morris Mason, their British headmaster, was young, progressive, and obviously respected by his students. And his school was a well-equipped plant. By contrast, the Government Boys' Secondary School nearby was the poor relation. Its students were all black. Here again, as in Uganda, I was reminded of my own old high school, and as in Uganda I felt thoroughly at home at this school in Tanga.

As I shook hands with George Hornsby, I told myself that here was no ordinary man. He was a stocky, fortyish, broad-shouldered Welsh-

man; and he was the school's headmaster. Clear-eyed and forthright, his brusque manner of speech was partner to a human warmth he could not conceal.

"What do you propose to tell my boys, Mr. Fax?"

The question was direct and unequivocal. I responded in kind, letting him know that I always stress the fact that I worked for my own education.

Mr. Hornsby's reaction was immediate. "THAT'S GOOD! Now *that's* what they need to hear. You see, sir, our boys are *poor*. They have nothing of the material like the boys over at Karimjee. And we expect nothing of the material from them. *But we do expect them to work and to learn.* Every boy has a job. And most of them come through nobly with both their work and their studies."

A sturdy young African approached the headmaster to inquire about an adjustment in the afternoon schedule. Hornsby responded that he hadn't forgotten. When the student turned away the headmaster asked me if I could delay my presentation for a couple of hours so his students could participate in an impending celebration. It was Africa Day, and the whole country would be observing the occasion.

A huge parade was scheduled for the early afternoon and all school boys and girls would be marching. By 4:30 P.M. the festivities would be ended and we could have our scheduled meeting. Besides, it was assured that I would enjoy seeing the sights as the school's honored guest. I quickly agreed with the arrangement.

As we continued our tour of the school's kitchen, where the simple but nourishing meal was being readied, Hornsby sampled the stew steaming in a huge caldron. "It is not fancy, Mr. Fax, but it is nutritious and well cooked," he murmured. In response to my question about his own youth, the headmaster replied with the alacrity of nostalgic pride. This man understood the meaning of material deprivation, for his was a large and poor family. His father, a Welsh miner,

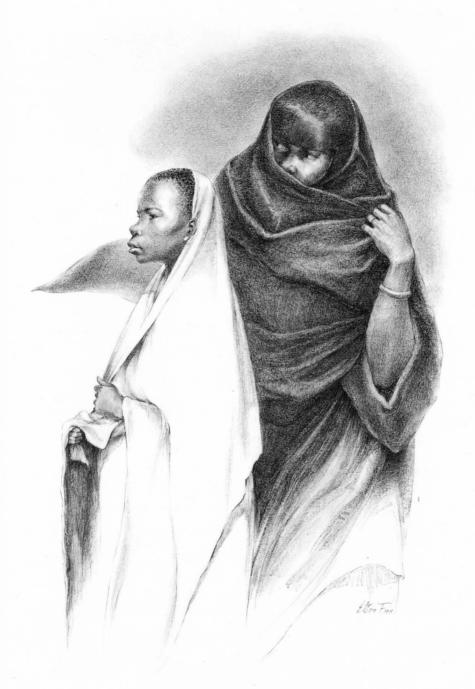

TWO MUSLIM WOMEN OF TANZANIA

was killed in a mine accident, and he left school to go in the mines to support the family.

"The six hundred pounds my mother received for my father's life

did not go very far. So I stayed out of school to help her for a while. Later I went back to work for the remainder of my education."

In that brief exchange I understood why my initial response to

CELEBRATING AFRICA DAY (TANGA)

George Hornsby had been so positive. Following lunch at the Hornsby home, I accompanied the headmaster to the large open field where a mass of gay spectators had already gathered to join in the festivities.

George Hornsby seemed to know everyone. Speaking first in Swahili, then in English, he introduced me to the city's officials and from them obtained permission for me to use my camera as freely as I chose. We did not have to look for sights to photograph, for they were already beginning to assemble all around us.

Clusters of spectators, men and women, gathered and sought points of vantage beneath the beneficent shade trees along the perimeter of the field. Some stood and others, especially the women, sat along the grassy edges. The women, normally careful not to expose legs, arms, and faces in public, struggled to maintain the tradition as excitement mounted. Their attempts to hold voluminous black outer garments decorously in place became more and more futile as the rhythmic band music swelled. The parade was under way.

By the time it was over I had seen hundreds of school boys and girls, African and Asian, marching together. Some carried banners and signs proclaiming in Swahili and English the determination to rid their country of all vestiges of colonial rule. Though spirited and vocal, the young marchers never broke ranks or otherwise relaxed the controlled discipline that characterized their demonstration. They were followed by the older agricultural workers, representing the union of sisal, coffee, and tea farmworkers. It was an impressive display of a people's expression of solidarity behind the leadership of a government in which they obviously believed.

In this regard one must remember that it was Julius K. Nyerere, president of the republic of Tanzania, who had taken the initiative in launching a broad program of nationalization in his country. Foreign banks and big businesses were his first targets.

Then, even with the presence of Asians in his government, Nyerere

was the first of the East African presidents to crack down upon those Indian and Arab traders who were said to be "milking the Tanzanian cow without feeding her." So the fervor of this celebration at Tanga implied enthusiasm for a leadership that would take positive action against traditionally established power.

Within one hour I was addressing the young men of the Government Boys' School. And at the conclusion of my talk they asked the same question students had asked in every country I had visited in both East and West Africa.

"Why don't Afro-Americans return to their original homeland here in Africa?"

I told them that while I could not speak for all Afro-Americans, I could and would answer that question for myself.

"I prefer to remain in America because it is as much *my* country as that of any other American, native born or naturalized. My African forebears who were forced into slavery in America helped build that country with their free labor. Not for a single instant do I intend that any racist in America will ever drive me from that which they helped build and of which I am a part and a rightful heir."

I said it quietly and firmly. And just as predictably as African students had asked me the question, they responded to my answer with spirited applause.

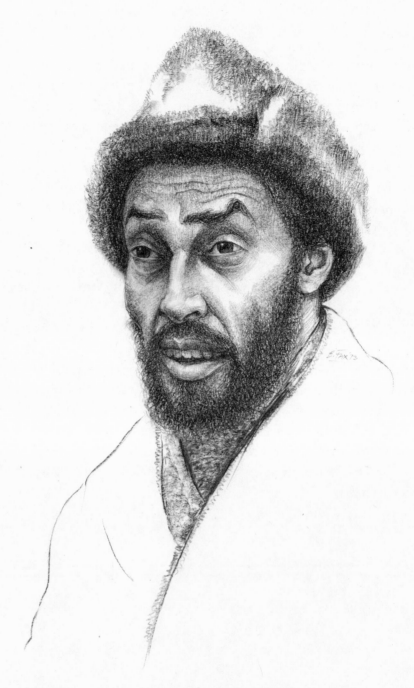

ONE OF OUR RUSSIAN INTERPRETERS

5

INVITATION FROM
MOSCOW

ALONG with the other male passengers I was carefully searched. They did not rely wholly upon electronic devices, as we do. The Soviets did it the old-fashioned way, frisking with the hands. They expertly patted my sides, back, front, and both legs from ankle to crotch. Then after looking through my hand luggage, they let me pass onto the airliner. Women and their hand luggage went through unchallenged.

Jean Bond, Jack O'Dell, and I, three black writers, had boarded the huge Russian Aeroflot jet at New York's Kennedy airport. I noticed that the majority of the passengers were non-American, mostly Russian. Our schedule indicated a nonstop flight to London for refueling and a change of crew, followed by a resumption of the flight to Moscow. The chilly November air outside made the plane seem especially warm and cozy. And that was good, for we would be in flight for twelve hours—six on the first leg and six on the second. I noticed how clean the aircraft was and that the flight was not crowded. There would be ample room for stretching out—just what I needed. Besides, I could spend a little time just thinking of the past two weeks in which I had to get ready for this trip. And I could speculate upon what might be ahead.

In the earliest pages of this book I had said that my trips to East Africa and to the Soviet Union were of vastly different natures and were made under different circumstances. They were indeed. I had further said that I had learned through previous observations how picturesque local color often covers a measure of human misery. Moreover, I had said that the exceptions to that had, in my experiences, been few and therefore memorable. Let me briefly compare the two visits.

I have already indicated how in East Africa I was in constant communication with students with whom I related in two ways. The first

UZBEK CHILDREN OF SAMARKAND

was on the basis of an ethnic kinship and the second on the basis of a common human experience with the racism of colonialism and post-slavery attitudes. While I could not relate to the peoples of the Soviet Union through bonds of ethnic kinship, I did spend most of my time with the nonwhite people of Central Asia. That their recent social, political, and economic condition paralleled that of my own people in America, as well as those of Africa, was a fact of history that made easy communication with them not only possible but natural.

As to my observations about local color as I had known it, I was to be surprised by some exceptions in Soviet Central Asia. As this narrative progresses I shall recall those exceptions and why they existed.

From the foregoing pages you know that I was sent to East Africa to talk with groups about my experiences as a black professional in the United States. The same format did not obtain in the USSR. Although I talked with many Soviet people, I was not obliged to go before audiences as a public speaker. And in my conversations in Moscow and Tashkent, I did indeed talk with my hosts about the position of the Afro-American at home, as I shall later indicate.

Still, it relieved me not to have to be as defensive in the Soviet Union as I had to be during my tour of East Africa. To anyone who has carefully read what I have already written, it should be quite clear that being an honest black American spokesman in Africa for any branch of the United States government tests one's stamina and resources at every level. Happily that was not required of me in the Soviet Union. Even so, I was faced with problems. In fact I had to struggle with myself to keep from dragging them to the Soviet Union with me.

Like all other Americans I, too, had been exposed to the popular picture of the USSR presented to us for a long time by our news media. We are all familiar with it, as the following italicized expressions will prove. The Soviets, we have been told, are a rugged, peasant people, and *they are a good people*. It isn't they but their *totali-*

tarian government of which *we of the free world* must be ever wary. That oppressive government, we heard, has *yoked its people with collectivism.* And collectivism, we were advised, *stifles individual human initiative and creativity.*

Indeed, there is very little creativity under communism, according to all I had heard. All contemporary art in the Soviet Union (with the possible exception of some performing artists and companies) has been rated *aesthetically poor and sterile* by many of our leading art critics. And finally, just about everyone in the Soviet Union is a *slave of the state,* according to our general information. There are a few notable exceptions, however, who defy the status quo and find refuge here if they can *make their escape from behind the iron curtain.* When that happens their stories get wide publicity in our newspapers, and we see their faces and hear their voices on television. That is the extent of the knowledge most of us Americans, until quite recently, have gleaned from our press about the USSR and its people. We have all been prejudiced by it.

From such reports I could draw only two conclusions. The first was that if those stories were completely accurate, I would have to believe that the Soviet people were uncommonly dull and passive to put up with so tyrannical a government. Moreover, if they were that apathetic and stupid, they could not be the same revolutionaries I had been hearing about. The second was that I would have to be content to take in everything I could read and hear about the Soviets and wait patiently until such time as I could go and see some things for myself. In that case I would be in a position to form some judgments of my own.

Such an opportunity did come. That it came as a complete surprise to me I have already indicated in my prologue. And I must admit right here that along with the thrill accompanying that unexpected chance, I experienced a few momentary twinges of suspicion.

Why was *I* chosen as one of three Afro-American writers to make

such a trip at the expense of the Union of Soviet Writers? I had never considered myself that important. And though I have always voted except when I wasn't allowed to in the South, I have never been active in *any* political party. Nor can I think of any place where I exert any particularly noteworthy influence. But the exciting prospect of the trip quickly eliminated all such doubts. And without hesitation I cheerfully packed my bag and gratefully set forth for Moscow and whatever else might lay beyond.

It was snowing lightly when we arrived in the late afternoon and were met by four representatives of the Union of Soviet Writers, two women and two men. Frieda Lurie, the older of the two women and a member of the foreign commission of the union, took immediate charge of things. She was a short, plumpish, well-dressed, and most pleasant lady. Her manner was as genuinely warm as her handling of both English and Russian was swift and sure. The same could be said of Nadia Prebitkevitch, the younger woman.

Nadia, twenty-five, tall, slender, and very attractive and chic, could easily be mistaken for a model. A native Moscovite, she worked as a translator together with Frieda at the Commission. Because the initiative in greeting us and getting us easily through customs at that airport meeting was so thoroughly and efficiently taken over by the two women, the men, though polite and cordial, seemed secondary and all but not present. One, however, turned out to be Alexander Nakolukin, professor of philosophy at the Institute of World Literature in Moscow.

We were chauffeured by a most careful driver over the thirty-kilometer route separating the airport from Moscow. Indeed, as a licensed driver of some experience, I was impressed by the deliberate care with which the many motorists were driving through the light snowfall. Though it was nearing 5 P.M. and workers were already on the highway homebound from their jobs, they did not rush over the slippery pavement, as is often done along the roadways leading into

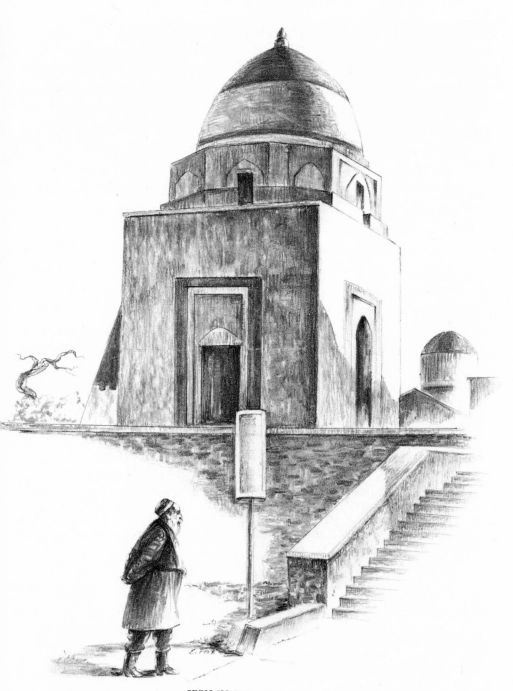

SEEN IN BUKHARA

New York City. Nadia told us that car collisions are taken rather seriously by Moscow authorities.

We entered the Moscow city limits a little past five-thirty and it was already dark. Traffic, though fairly heavy, did not seem congested as it moved along the wide streets. There was relatively little horn-honking, as foot patrolmen, aided by automatic signal lights, directed the flow of motorized and pedestrian traffic. Workers poured out of the shops and stores as they walked to the nearby subways and bus stops. I looked at the shop windows. Most were filled with bright Christmas decorations, complete with tree ornaments, miniature Santa Clauses, gay lights, and merchandise. It was a familiar seasonal sight.

As our car crept along and stopped at various points I had a chance to get my first look at Moscow's working people. What I saw surprised me a bit, for I had expected them to be far more glum, drab, and shabby. That is the picture we in America had been given of them by our press. Instead, I found them quietly and conservatively attired but warmly and quite adequately prepared for the weather. Few seemed threadbare, and certainly they were ruddy faced and apparently able to afford life's necessities. But I would have to wait until I saw them in the full light of day or indoors, where they would not be bundled in boots, overcoats, and fur hats. I could then make a better assessment.

Our hotel, The Russia, located in "Old Moscow," was within easy walking distance of Red Square, where I would later amble close by Saint Basil's Cathedral, the Kremlin, the Lenin Museum, and Gums Department Store. At the moment, however, dinner in the dining room of the six thousand-room hotel and a good night's rest were the immediate needs. After taking care of our passports and hotel registration, Nadia gave each of us 140 rubles (about $170), which she told us we should use for our meals, except of course when we would be invited out to eat. That sum, to last us for three weeks, was quite

sufficient, I later learned, for we were invited out frequently.

Our hotel rooms were large, high ceilinged, and by no means over-heated. Still, they were not uncomfortably cold. The double windows served to insulate the building from the low temperatures and high winds of winter. I had been cautioned to take Kleenex with me, for it is as scarce as toilet tissue is sparse and coarse. What the Soviets do with their paper is something I shall shortly describe. Vast as the hotel was, it was prevented from being impersonal by the presence, around the clock, of a woman assigned to a desk on each floor. It was to her that we turned in our keys and made our requests for various special services. Following a dinner of fish, salad, potatoes, wine, and ice cream, I went to bed.

Though daylight did not arrive until after eight o'clock, I could hear the people outside my window on their way to work. Jean, Jack, and I breakfasted at one of several snack bars located throughout the upper floors of the hotel. Fruit juice, eggs, sliced salami, cold chicken, various types of breads, and hot tea were available for a few kopeks, though a fresh orange was a luxury and therefore expensive. At ten o'clock we went down to the lobby to meet Nadia, who had a taxicab waiting to take us to the headquarters of the Moscow Union of Soviet Writers.

Our driver was one of a host of wild ones. Although like most other Moscow cabbies, he was careful never to run through a red light, he made pedestrians either pull up short or run for cover. At one point he and an old lady he had stopped short of hitting engaged in a mild ten-second debate before she matter-of-factly mounted the sidewalk to safety. A week or so later Jack and I argued with Nadia about what we held to be the inalienable right of the pedestrian to walk the streets in peace and security. We pointed out to her that man walked before he invented the wheel, and that while New York City's drivers are just as bad, those of California are held in check by more strictly enforced laws. We suggested the same might be good for both New

York and Moscow. Though Nadia was not inclined to concede that we might be right in our criticism of the driver attitude toward pedestrians, I think she began to cogitate on it. Meanwhile, I am certain the wild drivers of Moscow have not changed their ways any more than have those of New York City.

Out there on the busy thoroughfare I took careful note of women working everywhere along with men. They dug in the streets, swept and shoveled the snow, and operated the buses and trolleys. Many of them were obviously well past thirty years old. But muscular heaviness by no means characterized all of them, for there were also those with narrow waists and flat stomachs. Indeed, one of the most incredibly beautiful women I have ever seen anywhere was a ballerina I watched close-up later that evening at the Kremlin Palace of Congresses. But I am rushing ahead of my story.

At the headquarters of the writers' union we were greeted by Valentin Kotkin, secretary general of the foreign commission. Also present was Alexander M. Nikolaev, deputy chief editor of the magazine *Friendship of Nations*. Mr. Nikolaev, a poet, had lost an arm during the Soviet defense against the invading Nazis. There were others present, too, men and women, and of course there were Frieda and Nadia. Even though Mr. Kotkin's English is excellent, he preferred to speak to us in Russian, allowing Frieda to interpret for us. During the course of our briefing he answered practically all the questions I had been entertaining, not only about the writers group itself, but about what it had in mind for us while we were there.

We were told that Maxim Gorky had founded the writer's union in 1934, and that the building we were meeting in had been an estate of one of Moscow's wealthy families prior to the Revolution. It was made clear to us from the outset that this organization is *not* state controlled. Its membership of seven thousand is composed of writers mainly between forty-five and sixty years old, and it has a branch in each republic of the USSR. Its own publishing house serves as a

starting point for unpublished writers, who often become established with other houses. The union's own publishing house provides, through advance subscriptions, a guaranteed circulation for what it produces, making retail outlets for its books unnecessary. Authors published by this house are guaranteed a "sizeable sum of money" upon the agreement to publish their works, and they are not obliged to depend upon royalties accruing from across-the-counter sales of their books.

After describing the social benefits extended to its membership by the union, Mr. Kotkin told us that we were the first of several groups of black American writers they expected to receive in their program of exchange. He said, "You will see a few places here in Moscow before going to Uzbekistan, Georgia, and Leningrad prior to returning here to Moscow."

Then he surprised me with this: "We want you to see and do some of those things *you* specifically want to see and do. If you will let us know now what they are we shall do everything we can to arrange them for you. And if you have any questions or any doubts about anything please feel free to express them to us now or later—as you desire."

I wanted to know if I would be restricted in the use of my camera.

"Except for the Tomb of Lenin, especially the interior, you are free to photograph anything you wish."

We asked if there would be even a small amount of time for us to explore and look about on our own, and if we could feel free to talk with people at random.

"Yes, you may. Actually, we want you to."

I said I would like to see a collective farm, an art school in session, some art shows, and the theater.

"The collective farm and theater are on the agenda and we shall see that you visit several exhibitions and at least one art school."

Jean and Jack had their requests and were likewise assured they

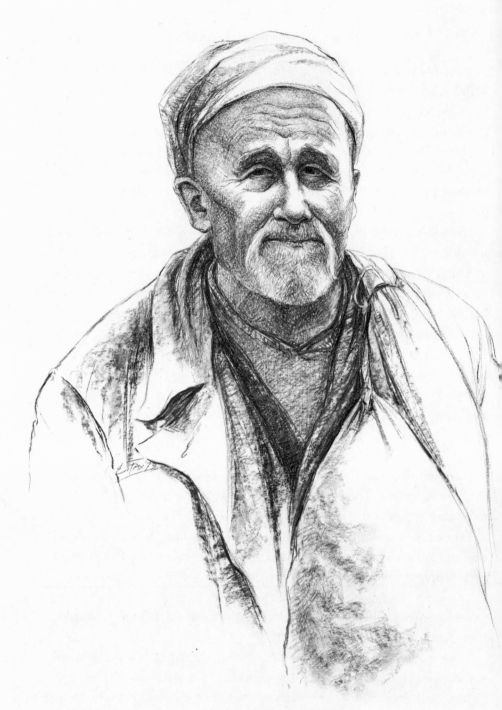

SEEN IN SAMARKAND MARKET

would be honored. (I should add here that our hosts were true to their promises.)

Following the meeting, we were taken to a delicious midafternoon dinner in the writers' own dining hall, where we were served a meal complete with hors d'oeuvres, soup, main dish, dessert, wines and vodka aplenty. From there we visited the Lenin Museum and had barely enough time to get to the ballet, where we saw Gautier's *Giselle*, beautifully performed by an excellent company. It was there at the theater, formally called the Kremlin Palace of Congresses, that I had a good look at the stunning, aforementioned ballerina star, as well as at Moscovites out for an evening of cultural pleasure.

The palace, built in 1967 to commemorate the fiftieth anniversary of the revolution, seats six thousand at prices ranging from three rubles top (a ruble is valued at a trifle more than a dollar) to approximately less than a dollar. That makes it available to people at all economic levels. Some of the patrons were modishly dressed and others were more simply attired. Bright colors and the light use of cosmetics and some miniskirts were favored by the women. I recall few, if any, heavily shadowed eyes, false eyelashes, wigs, extreme miniskirts, or pants suits among them. And hippies in dungarees, long hair, beards, pendants, beads, and other assorted paraphernalia familiar to us were here nonexistent.

Three flights up via escalator took us during intermission to the refreshment area, where ice cream, cookies, cakes, and bottled soft drinks were liberally bought and consumed. Soviet ice cream and cookies are superb and they are popular. While having some I spotted two young black men chatting amiably together and made my way over to them. Both were students, one from Philadelphia, Pennsylvania, the other from South Africa via Zambia. At the end of the performance I marveled at the swiftness and precision of the hat and coat checking system that dispensed several thousand articles of clothing with no crowding, jamming, shoving, or misplacing of garments.

Back in the solitude of my room at the hotel I had much to think about. That my invitation to visit the USSR had propagandistic implications was without question. And what was wrong with that? Nothing. All nations, including our own, seek in some way to make themselves as attractive to outsiders as they possibly can. So why should the second most powerful nation on earth hesitate to show its best features to us? Whenever their visitors come to New York City, they surely are not given a block-by-block view of the ugliest sections of the South Bronx or Brownsville in Brooklyn. Frieda Lurie, who has been here, has never seen inside a black person's home. She has since told me she was always too heavily programmed and too closely "guarded" by her American escorts to visit any of the black American friends she has here. And I must in all fairness say here that I *was* invited to the homes of two of our hosts when we visited the republic of Georgia. But that is yet another narrative for another time. What I began to wonder as I lay there in my room in Moscow, thinking of many things, was just what places there were in that vast city I would not be shown and just what was transpiring in such places.

Visions of the evening recalled the young man, Chris, whom I had met at the theater just a couple of hours previously. Was he, I wondered, one of those African students who, according to what I had read in New York, had been so shabbily treated in Moscow? He gave not the slightest outward indication of being unhappy there, but that meant so little. As a black South African, he, like his counterparts in America, had learned to wear a mask. Automatically my thoughts drifted to Norris Garnett.

You will recall that he was the young, black, American Foreign Service officer for whom I had developed such a profound respect in Tanzania. Before I had even remotely dreamed of going to the Soviet Union, I had read disturbing news stories about Norris Garnett. And the bizarre events as I read them make it easy to understand why black Americans have come to harbor such distrust of their white

fellow countrymen. They also make one know why we Afro-Americans relate so easily everywhere to nonwhites who have shared our common experience with white racism.

Following his tour of duty in Tanzania, Norris, who speaks fluent Swahili and fluent Russian, had served our government in Moscow. In 1965 one of the major news services ran a story from Moscow in the American press stating that Norris Garnett had been asked by Soviet authorities to leave their country. According to the report he had "turned African students against the Soviet Union." At the time, Garnett was characterized in the American press as "a capable diplomat."

The news item was brief and I never heard any of the details surrounding the circumstances. However, the next news of Garnett to reach me appeared three years later in *Jet* magazine for September 26, 1968. In exactly eighteen lines it stated that the thirty-six-year old cultural affairs officer for the U.S.I.A., who was ordered out of Moscow three years earlier, announced he was quitting the U.S.I.A. on grounds of discrimination. The following is a direct quote from *Jet*.

"It is the same old story," said Norris Garnett, an eight-year veteran of the U.S. overseas operation. "A black can't get ahead." U.S.I.A. aides in Washington said the diplomat was assigned to Vietnam. Garnett charged he was being "railroaded."

Just what did happen? It is not inconceivable to me that in "moving ahead" an American Foreign Service officer would perform an act of sabotage for his government or that he would be caught at it. That at least is what the story implied. Still, to anyone who has dealt even briefly with Norris, the incidents as they were reported seemed woefully incomplete. Relaxing in that Moscow hotel, thinking of Norris and of what may have happened to him, I recalled yet another incident Langston Hughes relates in one of his autobiographical narratives.

He tells in *I Wonder As I Wander* of the big-name American news

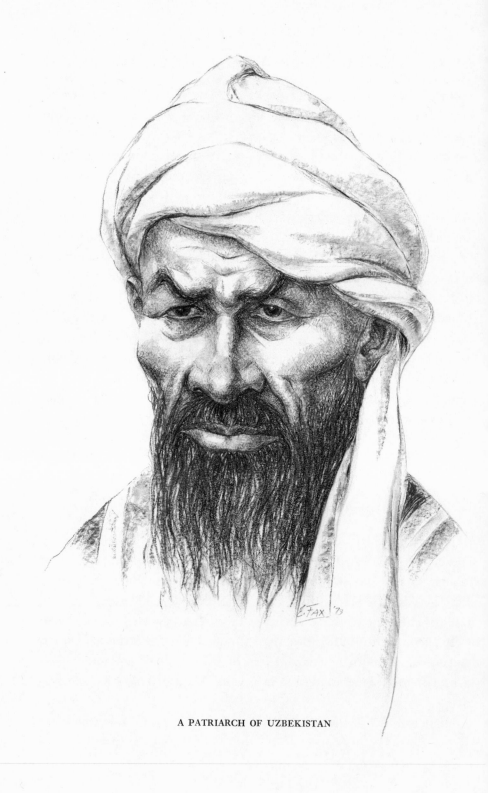

A PATRIARCH OF UZBEKISTAN

correspondent in Moscow who reported some years ago that Langston and a group of Afro-American actors were "stranded, starving in Moscow, unfed, unpaid, and destitute." Hughes says that the writer knew better. He had, according to Hughes, seen them all spending money daily at the expensive Metropole dining room and bar. Writes Hughes:

When we showed him the clippings that had reached us by air, he simply grinned. The papers for which he wrote were anti-Negro and anti-Soviet.

Had Norris Garnett fallen victim to racist-inspired news reporting? For a while my thoughts were a maze of contradictions. Finally I rolled over and went to sleep.

Before leaving Moscow for Tashkent, we made two more significant visits. One was to the House of Children's Books, where we were taken by Frieda and Nadia, our constant companions and escorts when we were not meandering about on our own. Six hosts awaited us. They were Nina Pilinik, director, Konstantin Piskunov, Eugene Rechev, Nina Dresdova, Boris Dekhterev, and a Mr. Boronetsky. Mr. Dekhterev, chief artist of the publishing house, was the spokesman.

"This publishing house puts out 160 million of the 270 million children's books published in the Soviet Union. In addition, 300 million textbooks are published yearly for children here in our country. With us the publishing of children's books is a most important thing."

The speaker, a small, slight, graying man, winner of the Lenin State Prize and called "The People's Artist of the Russian Federation," is an excellent book illustrator. So is Eugene Rechev, a heavyset man who more clearly resembles a successful salesman than the master of the satirical pencil and brush that he is. I was given several of the books, and from what I gathered, good writers and artists for children's books do rather well in the USSR. There is certainly a lot for them to do.

Incidentally, I was fortunate in having taken on the trip with me

several copies of the books I had written, as well as copies of my portfolio of black-and-white drawings titled, *Black And Beautiful*. It pleased me immeasurably not only to offer the reproductions and the books to our hosts as gifts but to note their approval of, and enthusiasm for, my own craftsmanship. I even made a few quick on-the-spot sketches. In that sense I was able to carry through the idea of a cultural exchange with our Soviet hosts.

I learned also that this house is the world's largest publisher of books for the preschool child, with an output of forty million annually. Its artists are of the highest caliber and its printing, selection of type, and binding of first-rate quality. I said earlier that I would make a pertinent comment about the Soviet use of its paper resources. I found the best of it not in bathrooms but bound between the covers of the loveliest and the least expensive children's books I have yet seen anywhere. And with that accent on youth much in our thoughts we were, appropriately enough, taken to the Moscow City Pioneer Youth Palace.

Because I shall later describe another similar visit in Central Asia, I shall here state simply that this institution, founded in 1922, has branches throughout the other Soviet republics. Children from five to seventeen years old attend the clubs after school, where they receive special training in sports, technology, and art. Among the seven pledges they take are that they must "embrace the philosophy of international solidarity and be acquainted with the conditions of other peoples of the world." I was again to be made aware of the Soviet emphasis upon the theme of "international solidarity." It would occur in Uzbekistan, where Valentin Kotkin told us we would be going in just a few hours.

Langston Hughes had written in 1956 that when he was in Uzbekistan twenty-four years earlier, the region was not generally open to visitors. He and the group of black actors with whom he had traveled to Russia in 1932 were able to get there only through a stroke

of luck. One of the pretty black girls in the group had charmed one of the Russian officials and he had arranged the issuance of a press card for Central Asia to Hughes. Today the area is open to visitors. What remarkable changes forty years have brought about!

A REMNANT OF THE UZBEK PAST

6

I "DISCOVER" UZBEKISTAN

THE DEPRESSION was still upon us. America was on the threshold of World War II, and along with thousands of others I was eking out an existence in New York as an employee of the temporary WPA art project. The Works Progress Administration program was an emergency innovation of President Franklin Delano Roosevelt's early administration. It provided temporary work for the great masses of jobless Americans; conservative Republican foes, the nation over, hated it. Indeed they hated everything the president sought to do for the people at large.

The anti-Roosevelt press called him "a friend of the Communists" and they even said worse things about his wife, Eleanor. Even those with few opinions about anything else suddenly became authorities on what they considered the evils of "Roosevelt's pro-Red learnings and dangerous socialist schemes." Many of the poor, whose civil service jobs or private employment kept them off the nationwide WPA rolls, also became critics of the president and his programs. Their anti-Roosevelt rhetoric, so closely tied to their anti-Communist outbursts, automatically linked the WPA and its workers to subversion.

Many of us were confused and dismayed. After all, the projects

were providing some kind of work for thousands of Americans such as I. Surely the critics were offering us nothing. And I noticed yet another thing. Those privately employed poor were far from being as secure as they thought they were. I was to bear witness to a tragic example of that, which I shall momentarily relate.

A bitterness settled upon many of us. I could not forget that even though I was a well-trained graduate of Syracuse University, I was, because of my WPA employment, considered by many to be lazy, incompetent, and "Red." And I *had* to seek some means of restoring my dignity and a measure of faith in myself. I began to find it in a new and then controversial book titled *The Soviet Power*. It was written in England by the Reverend Hewlett Johnson, often referred to as "The *Red* Dean of Canterbury." Though too impoverished to buy books, I borrowed a copy of *The Soviet Power* and I read it. For the first time in my life I learned that there was such a place called Uzbekistan and that the history of the fight for human dignity waged by its nonwhite people was something to which I, a black American, could relate.

Until then, however, and along with most Americans, I, too, thought of the Soviet Union in terms of one place, and one place only. Russia. I had, of course, heard also of that remote place called Siberia, which I envisioned as a kind of Arctic Devil's Island, to which hapless Russian dissenters were banished—forever. What a limited concept I entertained of the world's number-two nation!

The Union of Soviet Socialist Republics is just what its name says it is. Its territories (or republics) spread from Europe into Asia over an area more than six thousand miles wide and three thousand miles long. That is twice the size of the United States of America. Two hundred and forty million people live within the area that includes fifteen distinct Soviet republics. The largest of those is the Russian Federation, which is located in both Europe and Asia. Uzbekistan is one of the fourteen other Soviet republics, and is located in Central Asia, just above Afghanistan.

Having already said that I first read about Uzbekistan in Hewlett Johnson's *The Soviet Power*, I discovered to my surprise that he referred to Uzbekistan as a territory in which the Russian czars had:

cultivated the feudal patriarchal system and found traitors, such as the Emir of Bukhara, more attached to their class privilege than to national pride as their ready tools.

Even as I read that statement I unhesitatingly related the circumstances in Uzbekistan to certain aspects of slavery in America. My own paternal grandfather had, as a boy, been a slave in Maryland. One aspect of slavery to which I related the Johnson quote was that in which a few privileged slaves could always be counted upon to spy upon fellow slaves and report to their masters any seeming irregularities or deviations from what a slave was normally expected to do. For such services the informers were relieved of heavy workloads. Instead of wearing rags they wore the cast-off clothes of their masters and they dined on scraps from the tables of the "big house." Some even lived under the master's own roof.

Since the abolition of slavery in America, there are among our people those still possessed of the "slave mentality." They easily acquiesce to the demands of racism, which is slavery's heir. There are others who think and behave quite differently. One of the former comes to mind, and it is he to whom I alluded a bit earlier when I said that all poor workers during the Depression were not as secure as they might have imagined.

I knew this man well and I shall call him Morris, though that was not his name. He worked for, and lived in the New York home of, a wealthy white industrialist, who was a Roosevelt hater. The man's political attitudes were echoed by his servant Morris. Mimicking his boss, whom he worshiped, Morris constantly and snidely referred to the agency that enabled me to feed my family as "that goddam W. Piss A." And he forever warned me to "stay away from those Communists who are telling Roosevelt how to run this country." He would

solemnly intone, "My boss has told me all about them. All they want to do is take everything away from those who have it without working for anything themselves."

Morris, I was to learn, had a little something of his own. He had won fifty thousand dollars in the Irish Sweepstakes at a time when federal taxes were low. And the only time he ever mentioned it was to say that "my boss has invested the money for me." I believed him. I also believed that over the years the original sum had grown to a considerable amount. Still, Morris, no longer young and believing implicitly what his boss had promised him by way of a wealthy old age if only Morris would continue to serve him, refused to go on his own.

Then Morris fell terminally ill, and his boss placed him in a moderately priced out-of-town nursing home operated by a black woman for black patients. During Morris's confinement, which was not of excessive duration, his boss somehow managed very well without him. Then Morris died. When his only heir, a nephew, appeared to collect the dead man's fortune, he was curtly told that his uncle's illness had absorbed every cent of it. No one close to the scene ever believed that. And I have strong misgivings about Morris's boss, who never ceased to bait the "Communists," whom he declared were "out to take from those who have, rather than work for their own."

On the other hand, there are those noble black Americans who are by no means possessed of the slave mentality. As I read Hewlett Johnson's book, it gratified me to find a reference to one such distinguished name. At one point in his narrative Mr. Johnson had described the reaction of Soviet citizens to Paul Robeson and his to them. And he used the following Robeson quote to support his claim that Robeson himself felt he had found acceptance there:

Everywhere I went I found the same welcome, the same warm interest, the same expression of sincere comradeship toward me as a black man, as a member of one of the most oppressed of human groups.

THE MODERN UZBEK WOMAN

I recalled how white America began shortly thereafter to squirm under the statements of Paul Robeson—how other prominent black Americans were quickly called upon to repudiate him and what he

was saying. I also remembered how the American stage, and the movie and recording studios that had previously found him so great an artist, suddenly and collectively closed their doors to him. Not only was he denied work in his own country but he was denied the right to travel abroad where he was wanted and where he could earn a living.

I began to grow really apprehensive about social attitudes in my country when, a bit later, I was to live for a time in Mexico, and from there to travel on a United States government grant to South America and the Caribbean. In each place I, too, became conscious of that same human warmth and sincere comradeship toward me as a black man that Robeson had felt in the Soviet Union. It was a spirit that white America did not (and even now does not) extend to black America. With that as my personal experience, I could not join those damning either Paul Robeson or Hewlett Johnson's book. The latter, with its sections on "The Equality of Races," "Soviet Women in the East," and "Awakened Asia," made a profound impression upon me. It gave me my first insights into the condition of Central Asians and how their destinies were so closely tied to mine.

I found an even more personalized account of conditions in Uz-bekistan in the aforementioned autobiography of Langston Hughes, titled *I Wonder As I Wander*, published in 1956. Hughes, with whom I had more than a speaking acquaintance, had also lived in Mexico, and I made certain to consult with him before taking off for South America. Langston Hughes had excellent contacts in various parts of the world. His own exciting visit to the USSR took place in 1932, preceding mine by nearly forty years.

Langston was one of a group of twenty-two young, black, Ameri-can, aspiring actors who had been organized in Harlem to pay their own passage to Russia to make a film, for which they would be com-pensated over there. Hughes was invited to write the English dia-logue. His contract for four months' work seemed an unusual oppor-

tunity at a time when Hollywood was not employing black writers. Meschrabpom Films in Moscow was perfectly willing to engage him.

The story, titled *Black and White*, had its locale in Birmingham, Alabama. It treated the theme of black heroes and heroines (steel-workers and domestics) struggling for union solidarity under the direction of a dedicated white labor organizer. The villains were the white owners and bosses of the mills, who were pitting poor white workers against the union and the blacks. While Hughes found the film's premise sound enough, he had quite a job straightening out a few details of black-white relations in the American South. And only two of the troupe had ever previously been on any stage or before motion picture cameras.

Some work was done on the film, however, and during intermissions the active, young, black Americans had a great time just galavanting. They were frolicking at the Odessa seaside resort when word came to them that Meschrabpom had canceled the project. They would, however, be paid for the duration of their contracts, and passage back to the United States would be provided for those who wished to leave immediately. All others were offered the choice of exit visas at any time; an extended tour of the Soviet Union before leaving; or work in the Soviet Union for any desiring to stay permanently. And, adds Hughes in his autobiography, "All were invited to stay in Russia as long as we wished."

Three men elected to remain, eventually learning the language, marrying Russian women, and taking an active part in Moscow life. Langston Hughes and the others decided they wanted to see those sections of the Soviet Union where the majority of the colored citizens lived. That, of course, was Uzbekistan in Central Asia. As I have previously said, Langston secured a permit not only to tour but to remain for a while in Central Asia, where he proposed to write about it for American publications. I have already indicated how, although the area had been off limits to foreign visitors, he and his companions

were permitted to enter. And while the others, finding its largely rural and then undeveloped character much too rugged for their urban tastes, quickly left, Hughes remained alone.

Arriving barely fifteen years after the change-over from czarism to communism, he did indeed find the area rugged. I read with interest his report of visiting several cotton kokholzes, the Cotton Trust at Tashkent, and the Cotton College. And I was quite surprised to learn that at a Soviet collective forty miles from Tashkent Hughes found (and here I quote him):

There were about a dozen American Negroes attached to the cotton experimental farm, most of them from the South. Some were agricultural chemists, graduates of Tuskegee or Hampton, others from Northern colleges, and some were just plain cotton farmers from Dixie, whose job it was in Soviet Asia to help introduce American methods of cultivating cotton. . . . It was an oddly assorted group of educated and uneducated Negroes a long way from Dixie—and most of them not liking it very well. Conditions on the Soviet Collective, while a great change for the better for the Uzbeks, were for Negroes from America more primitive than most of them had known at home, especially for the younger college people.

As I read I wondered how they came to be sent, or invited, to that part of the Soviet Union in the first place. Then in 1960 I met and became friends with John and Bessie Sutton. John, who speaks fluent Russian, had lived in the Soviet Union. In fact, he had preceded Langston there by a full year and was working there at the time of the latter's visit.

The eldest of fifteen brothers and sisters, of whom New York City's black borough president of Manhattan, Percy Sutton, is the youngest, John is a scholar and a teacher. Born and reared in Texas, he attended Tuskegee Institute where he became Dr. George W. Carver's best pupil. When the Soviet government offered Dr. Carver what Carver himself described as "a vast sum to go there and work with their agriculturists, the great scientist declined, as he had declined a simi-

lar offer to work with Thomas A. Edison. He did, however, recommend and send talented and handsome young John Sutton in his place. That was in 1931, and John remained there until 1938. Between the time of our meeting and my own journey to the Soviet Union, he told me about his experiences as a black American there.

"I was in Uzbekistan where the people themselves told me how badly they had been treated by the Russians before the Revolution. The Russians often referred to Uzbeks as 'yellow dogs' and treated them just as whites in America have been treating us."

I asked John Sutton about marriage between Russians and Central Asians.

"Before the Revolution it was unheard of and it was not commonplace when I was there. There is no law prohibiting it today and old prejudices die slowly, you know. But the young people are far more flexible in such matters than are their elders. Changes are happening."

We both laughed about that, for we know how similar American sentiments are on interracial marriages. And we agreed that it becomes a meaningless mockery whenever white America begins to tell black America how racially intolerant some other nation is to its own citizens of a different color. At another time John told me this:

"A Russian girl and I fell in love and we were married in Tashkent. Now there was no objection among her people to her marriage to me, a black man. After all, the Russians worship the memory of Pushkin, who, himself (so legend has it), went out of his way to extoll the virtues of his African ancestry. My being an *American*, however, did raise a few doubts with them."

John Sutton's Russian wife died shortly after bearing him a son, who today lives in the Soviet Union with his own family, with whom John has recently visited. Returning from the Soviet Union under a burden of personal sorrow was but one small area of John Sutton's trouble. For several years thereafter he found it impossible to obtain gainful employment, even though a rash of wartime employment was

spreading throughout the nation. Even today he speaks of that period with some bitterness.

"Because of my extended stay in the Soviet Union and perhaps because of my training and experience I was accused here of being a Communist. Only when the Afro-American newspaper in 1943 printed that letter to its publisher, Carl Murphy, from Dr. Carver in which Carver said I had been sent to the Soviet Union as his replacement, was I able to satisfy the witch-hunters that I was not a national risk.

"But, Elton, if you have the opportunity to visit the USSR by all means go! And if you can manage to get to Uzbekistan, go there too. You will find the Uzbeks so like our own people. After all, they, too, are among the colored peoples of the world."

John Sutton had made the region sound so vibrant I immediately proceeded to do a little advance reading on its history—just in case I might get to see it. What I found was so fascinating I offer the following condensed version to the reader.

Uzbekistan is a trifle larger than California and is about two thousand five hundred miles southwest of Moscow. It is situated directly north of Afghanistan and northeast of Iran, and its temperatures range seasonally from torrid to frigid. From nine to ten million people occupy its land. Whatever may be the lacks and the handicaps of today's Uzbek people under the Soviets, nothing can compare to the misery of the restrictive existence they endured under the czars prior to 1920.

What is now Uzbekistan was once the ancient province of Persia called Sogdiana, which was conquered by Alexander the Great some three hundred years before Christ. In the eighth century A.D. it was taken over by Arabs, who introduced the Islamic faith that still exists there. Then the feared and hated mongol conquerors, Genghis Khan and his descendant, Tamerlane, took control during the thirteenth and fourteenth centuries.

MISTER FIVE BY FIVE

It was Tamerlane who established Samarkand, the city of his birth, as the center of his expansionist activities. Although turbulence was severe and the masses of people suffered privations, there was pros-

perity and even fabulous wealth for the top few. The latter lived amid culture and luxury in the cities of Tashkent, Samarkand, and Bukhara, each being located on major trade routes to China, India, Persia, and Europe. But the flourishing empires of Tamerlane and his successors began to crumble in the fifteenth century. Then came the Uzbeks.

Taking their name from Uzbeg, a former Turkmen leader, the Uzbeks extended their domain into parts of Persia, Afghanistan, and Chinese Turkestan. It was not long, therefore, before the Uzbek empire began to form into khanates and emirates closed to all foreigners. The best known were the khanates of Khiva and Kokand, and the emirate of Bukhara.

But those feudal kingdoms, providing spectacular wealth and comfort for their leaders while imposing the burdens of religious taboos and unrewarded labor upon their subjects, were not destined to remain isolated. Needy and greedy neighbors were eyeing Central Asia, and czarist Russia was one of the most formidable. The time was half past the nineteenth century.

Though much of Central Asia may be aptly described as barren desert and steppe, it was Russia's need to expand her external market for what she was beginning to produce that egged her on. Moreover, the arid land of Uzbekistan was ideal for the large-scale cultivation and production of cotton. Yet another consideration was the rival British expansionist program in Asia, which Russia was watching intently.

Central Asian resistance to the Russian advance would have been more effective had there been less internal squabbling in the Asian khanates themselves. Local feudal leaders were seeking to thwart the centralistic aims of the emirs and khans. The ensuing divisions and fratricidal wars imposed a consumptive drain upon the economy of the Central Asian kingdoms.

Having by the 1850s already seized the Great Kazakh steppes, Russia moved further in to conquer Tashkent in 1865. Three years later the khan of Kokand signed a peace treaty with Russia, declaring his

territory a Russian vassalage. He was followed in like manner by the khan of Khiva and the emir of Bukhara. Central Asia had become a Russian colony.

Conditions among the Central Asians during the middle 1860s were made to order for the Russian colonizer. Illiteracy was high, as was human mortality created by malnutrition and disease. Islam, with its restrictive hold upon the people, especially the women, was an ally upon which the conqueror could rely in holding the masses in check. Indeed, the women of Central Asia were the slaves of religion, their husbands, and their houses.

They had not always been so. But under the domination of Islam and the Turk, the once proud Eastern matriarch had been reduced to the indignity of being treated as the chattel of men. Declared by men to be "impure," Uzbek girls, forcibly married off at ages eight and nine, became the property of their husbands. As such they were treated no better than farm animals. And one must not forget that it was in Uzbekistan that the veil worn by Islamic women whenever they left the confines of home was a hot, foul-smelling, full-length covering of black horsehair. Czarist colonialism studiously sought to bring no respite to such torture of Uzbek women.

Maintaining a state of ferment in Uzbekistan enabled the Russians more easily to exploit their disunited colonial subjects. And Uzbek women were not the only victims of the Russian divide-and-rule tactics. National differences evolved into national hatreds with the banning of native tongues in secondary schools and universities. Boundary lines separating provinces and their respective inhabitants were arbitrarily drawn, resulting in the acceleration of group and tribal differences and rivalries. And the discord became binding as greedy and unscrupulous emirs and khans were encouraged to maintain positions of class privilege over their suffering people.

At the same time that czarist colonial rule in Asia was maintaining a harsh climate for its peasant dependents there, it did little better for its peasants in Russia. And since much of Russia and its European

ANOTHER PATRIARCH OF SAMARKAND

territorial possessions were agricultural even at the turn of the century, its people were quite properly termed peasants. They labored hard, because for the most part their equipment was primitive. Their constant battle against drought, blights, and fires kept morale at the lowest imaginable level. Illiteracy, ignorance, and filth were the norm for the rustic population. Only a few rich peasants (kulaks) fared better.

Workers in the towns were quite purposely handicapped by a czarist regime that feared the rise of a middle class. To prevent such a happening they discouraged initiative at home by offering their natural resources to foreign investors. The rich coal and iron deposits were made readily available to the French and Belgians. British and French had the oil wells at their disposal, while the textile mills and other factories were divided among German, French, and British capital. It naturally followed that under such an arrangement the condition of the native laborers would be miserable.

So long hours, low wages, shameful working environments, and even more shameful living conditions ripened the working class for their revolution. They were further goaded into rebellion as they observed the corruption in government that filtered all the way down to teachers, doctors, and military personnel. All exacted ridiculously high fees and demanded bribes from those they were sworn to serve. Such was the general atmosphere in Russia and its colonial territories in Europe. Even worse existed in the Russian colonies of Central Asia where czarist racism appended itself to the already unhappy lives of the people.

With the Socialist revolution of October 1917 came sweeping changes, and in 1924, exactly seven years later, the Uzbek Soviet Socialist Republic was formed. Today's modern Uzbekistan is the fourth largest republic of the USSR. What I recently saw and shall now describe of its people and its high productivity made me realize the incredible swiftness with which they are moving.

A PAIR OF OLD TIMERS

7

TASHKENT

THE LANDING signal chimed softly as the large jet plane banked to the right. I looked down. Gone were the dunes of the vast Kyzyl Kum desert, and in their place a thick blanket of industrially polluted air covered the city below. We were coming in for a landing at Tashkent, capital of the Soviet Republic of Uzbekistan.

Friendly rays of a thirsty, bright sun silently drank the puddles of rain that had recently settled on the airdrome's runways. And as our olive-skinned hosts welcomed us, it was hard to believe that darkness and frigid November air still embraced the city of Moscow. We had left there less than four hours earlier. The boots, fur hats, and heavy clothing worn in Moscow were not yet needed here in this central Asian capital of a million and a quarter souls.

Akram Aminov is a poet and he was our official host in Tashkent. He is also vice-chairman of the Uzbek Committee for Relations with Writers of Asia and Africa. A handsome, swarthy, dapper man under forty, he told us in crisp, fluent English that he also speaks Russian, Iranian, and the Uzbek tongue of his people. Though he lives and works in Tashkent, he is a native of Samarkand.

Akram was quick to let us know how pleased he was to welcome the four of us, Jean Bond, Jack O'Dell, Nadia Pribitkevitch (our Russian hostess), and me to Tashkent. It happened to be Nadia's first trip

141

also to that part of her country. The pride Akram took in the progress of his native land was obvious as he answered the questions we began to ask him about it.

He told us, for instance, that Uzbekistan is a sovereign state with its own constitution and Supreme Soviet (or Parliament), which appoints the government and issues laws according to the specific national features and needs of its territory. In a few days I was to learn more of the depth and perception of this young writer and scholar.

Along the route connecting the airdrome to the center of Tashkent, I noticed a number of factories whose stacks emitted huge billows of varied colored smoke. I had thought of Uzbekistan as agricultural rather than industrial, as I had been told that cotton was its number-one crop. So I wondered aloud in just what manner the factories I saw were related to the republic's farming activities.

"We manufacture *machinery* here," Akram said. So that was what accounted for the haze I had seen over the city—a haze similar to that which hovers over Gary, Indiana. The machines made in Tashkent include farm equipment, tractors, excavators, and textile machinery. And I learned that the Tashkent-made machines are both exported abroad and used in Uzbekistan itself as well as in other parts of the Soviet Union.

I looked carefully at the people along Tashkent's streets. Though many were obviously Russian, the edge in numbers belonged to the Asian Uzbeks. I noted how distinctly the handsome dark skin, hair, and eyes of the latter contrasted with the fair European complexions of their Russian countrymen. Some of the Uzbeks revealed plainly Mongolian facial characteristics.

Many of the men, young and old, wore the traditional black, four-cornered, embroidered skullcap proclaiming their Islamic faith. Women were much in evidence and their head-high, free-striding bearing offered full evidence of their emancipation. Not a single one was veiled, a fact that elated Nadia, whose Russian woman's libera-

OUR HOST, WRITER AKRAM AMINOV

tion manifested itself in her own resolute and confident manner.

That Tashkent had suffered a major earthquake in 1966 was indicated by the new public housing developments I observed there. Because more than three hundred thousand people had been left homeless by the catastrophe, the swift erection of replacement housing was mandatory. Help came to Tashkent from all areas of the Soviet Union. What kind of housing did they build? To those who are opposed to all public housing, what I saw in Tashkent will not be in any sense attractive. However, to one like me who finds low-income housing developments in large American cities preferable to the rotting, vermin-ridden slums they replace, Tashkent's new housing provides a sizable portion of that city's need. More is required, however, and more is planned for Tashkent, as Akram informed us.

I hardly needed to be told of the need. My artist's eye was as alert to what is yet to be done as to what is already accomplished. Looking sharply behind the shops along the neatly paved, tree-shaded thoroughfares, I caught glimpses of shacks and hovels inhabited by

those who have yet to be better housed. And I watched the dwellers of these miserable makeshift abodes, as well as those of the new housing projects.

That they were poor working people was fully evident. Surely, I had thought, a people so harshly treated by the czarist oppressors would reveal the familiar signs of a people stripped of their dignity. With no reason for feeling some sense of their worth, they could easily revert to the ways of the jungle, as physical rehabilitation alone will not heal the damaged spirit.

So I watched. How were the Uzbeks of Tashkent recuperating from their particular former travail? Just how were they deporting themselves, say, in comparison with poor residents of blighted cities of our country? At least a few answers lay as much in what I did *not* see as in what I saw.

I saw no knots of idle young men congregating on street corners, squandering time and annoying women passers-by. The one obvious public inebriate I saw was being so quickly hustled out of the marketplace by policemen, I scarcely had more than a glance at him. Not a single man, woman, or child did I see nodding in the doorways in that sadly familiar stupor of the drugged. No graffiti marred their public structures and carriers. Nor was I even once approached in Tashkent by a beggar or a street hustler.

Indeed, I cannot recall seeing even those relatively harmless itinerant street hawkers of jewelry and similar items who traditionally haunt the routes of foreign visitors. I do not contend that under no circumstances do such things exist in Tashkent. What I do contend is that if they were there, either they skillfully managed to elude my inquisitive vision or I plainly was not in the places where I could see them.

Those who are intractable in their feelings and thinking about the Soviet Union will counter with the assertion that the Soviet peoples are too thoroughly repressed and policed to be openly antisocial. That defies reason and history. Antisocial behavior exists among all peo-

ples; and history has shown that in any setting of extreme repression there are always those who will resort to open defiance—even at the cost of life. If that were not true, there would have been no people's revolution in America, in Uzbekistan, or anywhere else for that matter. Harsh policing merely stiffens the will to resist.

No, it was (and is) my feeling that the working poor I saw in Tashkent *preferred* to carry themselves with that air of human dignity and independence I so clearly recall. And more than most of the majority group in America, I have ample first-hand reason for understanding why an oppressed people do or do not deport themselves with dignity.

I was fortunate to have had the chance while in Tashkent to see the Uzbek Exhibition of Economic Achievements. Before describing it, however, let me here mention what skillful use the USSR makes of the talents of its women.

They are seen everywhere, working at everything, from performing manual labor in the streets to dominating in number the ranks of the medics in the hospitals and clinics. And I noted that along with having a variety of sizes and shapes, Soviet women do not have to be young and glamorous to hold highly visible jobs in public places. Many are not. That so many are chic and pleasing to the eye makes their presence all the more noticeable.

In Uzbekistan both Russian and Uzbek women share certain public jobs. Such was demonstrated when, although a young Russian woman escorted us to the Uzbek Exhibition of Economic Achievements, she discreetly stepped aside while an English-speaking Uzbek woman described the meaning of the displays. The lady's eager, chamber-of-commerce manner notwithstanding, she convinced me of the overall truth of what she said. Besides, there was no reason for me to expect that her comments should not have carried the ring of natural indigenous pride in what was being accomplished right there on her native soil.

Cotton is the agricultural monarch of Uzbekistan. Because of man's

ingenuity, cotton has maintained its kingly status there in spite of the
bleak desert land dominating the republic. High summer tempera-
tures and low annual precipitation have so challenged that ingenuity
that a massive irrigation program was begun in Uzbekistan in 1939. It
is still in progress. The prodigious scheme, along with projects related
to the cotton industry, were clearly designated in the exhibit I
viewed.

But cotton has partners in Uzbekistan's economy. The exhibit of the
silk industry prepared me for what I was to see in operation in yet an-
other Uzbek city and its outlying environs. There in Tashkent, however,
the karakul industry, oil refining, strip-mining of coal, and the processing
of other indigenous minerals were in progress. Coupled with heavy
and light machinery and rapid development in communications they
constituted memorable features of the exhibit.

I was especially eager, after viewing the cinema projecting equip-
ment, to talk with the film writers of Tashkent who, along with other
members of the Union of Tashkent Writers, were our hosts. Such a
meeting would soon transpire, and there was plenty to do in the in-
terim.

The accent on developing youth I had found in Moscow and Lenin-
grad obtained with equal fervor at Tashkent's Poineer Youth Center.
And their dedication to the principles by which they function was
fully evident on that day we three American blacks were welcomed
into the center by members of their International Club. At the door
each of us was greeted by a little girl of nine or ten, who presented us
with a lapel pin and a bouquet of white chrysanthemums. They then
escorted us inside, where the first thing we noticed was a huge por-
trait of Angela Davis. How fitting it was that here in Central Asia,
where racism was so well known, we would be greeted by a tribute to
the young and controversial black woman of California. Through our
interpreters we thanked them for their hospitality. And when we ex-
pressed to them our appreciation for their interest in Miss Davis, they

CHILDREN EN ROUTE TO SCHOOL

brought forth a large petition that each member had signed. It urged the release of Angela from prison, and they handed it to Jean to bring back to America so that our people here would know that they were with us in the fight to free black Americans from all forms of racial injustice.

Then we were entertained with vocal and instrumental music, and folk dances of both Europe and Central Asia. Boys and girls alike shared equal participation in the performances. Nor did we leave our hosts before being invited to join them in a group dance finale. Not only was it genuine fun, but a way of experiencing the feeling of peace and love through body contact of so universally natural and spontaneous a manner.

All along the trip, as in Moscow, I had been made conscious of a distinct lack of fancy tissue for bathroom use. What was available, while quite adequate, made no pretense at achieving the downy softness so persistently extolled in American advertising promotions. Facial tissues likewise were not to be found on the shelves of the stores. I soon learned why.

Though the USSR is not lacking the forests from which much paper is produced, it does lack easy means of *transporting* wood from the distant forest reserves to its paper mills. So the country must establish priorities in paper. Books and printed matter, therefore, take precedence over luxury items. The emphasis upon literacy, especially upon reading, in those parts of the USSR I saw, cannot be overstated.

People everywhere were reading. They stopped to read newspapers strategically displayed along the public streets. Magazine stands and bookstalls attracted small groups of browsers and buyers; and bookstores were packed with customers. I took particular note of one Tashkent outdoor bookstall operator. During the brief lulls when he was not waiting on clients, he sat with a book from which he greedily read.

The lack of paper for frills that I recall in Moscow was even more

EVERYONE WANTS BOOKS IN TASHKENT

noticeable in Tashkent. So it was quite in the literary tradition of the nation and the city that one of the finest pieces of printed matter I have yet acquired comes from the USSR. It was presented as a gift by Dr. Laziz Kayumov, a member of the Uzbek Writers' Union and a professor at Tashkent University.

The cherished item is a portofolio of reproductions in full color of miniature paintings illustrating the poems of Alisher Navoii. It is an exquisite example of the printer's craft. More than that, it is a reminder that Navoii, who lived between 1441 and 1501, is still regarded as one of Uzbekistan's greatest statesmen and writers. I became well aware of that at the Tashkent Museum of Literature, where I saw an impressive showing of the great poet's original works and their influence upon modern Uzbek literature. And for me the most impressive tribute to Alisher was the portrait by the local sculptor, Krumskaya. Simple and eloquent, it conveyed the very essence of the eminent man of letters.

It was entirely fitting, after that kind of introduction to the earlier literary art of Uzbekistan, that I would meet informally with members of the Tashkent Union of Writers. What rapport we shared! Their knowledge of, and interest in, the works of militant black American writers and artists in allied fields was gratifying, to say the least.

Certainly it came as no surprise, in view of the Uzbek national experience, that they would speak with reverence of Paul Robeson, Malcolm X, James Baldwin, Ralph Ellison, and, of course, Dr. W. E. B. Du Bois. Nor did I find the admiration for art and artists dedicated to man's continual struggle for liberation from oppression confined to their particular group. The Tashkent film makers were equally committed.

For forty-five years the film studio to which we were invited has existed and functioned in Tashkent; and from six men who were our hosts we learned that more than thirteen hundred persons are involved in cinematic activity in Uzbekistan. At that very studio were

nine hundred and seventy of them. Their technicians are all trained in Moscow. The films, we were told, range from the historically revolutionary to those of contemporary life. In addition to making films, the studios were constantly dubbing Uzbekistan dialogue into selected foreign-made pictures. Meanwhile, animated films for children were being increased from three to five features.

Our hosts were not hobbled by false modesty as they described their output as being of "high quality." Whatever their productions may lack, it is a reasonable certainty that they do not fall in the category of tawdry entertainment designed to make a fast ruble at the box office. That simply is not the way the arts function in the USSR.

Tashkent is memorable if for no reason other than our meeting with Oleg Stieffelman. It was with him that we engaged in a disagreement that canceled out a program he had planned for one of his English-language radio shows. Jean, Jack, and I were sitting together at the Tashkent airport, where we had a couple of hours to spare before taking a plane to Samarkand. We were approached by a brisk, well-dressed man apparently in his late thirties. He extended his hand in greeting to each of us.

"My name is Oleg Stieffelman and I am correspondent for the English department of Radio Tashkent. Welcome to our city. May we sit and talk?"

The man spoke quickly and in English bearing not the slightest trace of a European accent. As we three were about to have breakfast, we invited him to join us and he graciously accepted.

"I understand through the Union of Writers that you have been in Tashkent for a couple of days. Is that correct?"

We nodded in agreement, not at all surprised that a man who would be a complete stranger to us would know of our presence in Tashkent. He was a newsman, after all, and we three were a bit conspicuous even in the Uzbek capital. As we chatted over breakfast, we gathered that Mr. Stieffelman was a Soviet citizen of German

descent working in Tashkent, that he hosted at least one radio pro-
gram there, and that he was also a linguist with a thorough knowl-
edge of the English tongue. The latter was quickly apparent. Even
more than that was his easy use of *American* English, complete with a
few slang expressions. As is true of many in his profession, he was a
fast and glib talker. After an exchange of small talk he came to the
point of his mission.

"I would like to make a tape with the three of you—a tape in which
you would give your impression of Uzbekistan. Our radio program is
beamed throughout Uzbekistan and our listeners are always inter-
ested in hearing what foreign visitors think of their republic. What do
you think of that approach?"

He looked first to me for a response. Speaking strictly for myself, I
told him that in so short a time in Tashkent and with no opportunity
for reflective thought, the only comments I could make would be
about the weather, food, and general cordiality of the people. Such
comments, I suggested, would not only be banal but could possibly
affront the Tashkent Writers Union, our local hosts, not to mention
those discriminating listeners who might be expecting something of
more substance. Jean and Jack nodded their agreement.

Mr. Stieffelman then asked me in what direction I felt he should
slant the interview. Again making it clear that I was speaking for
myself and would readily accede to any majority-chosen counter-
suggestion, I said this:

"As a black American with a very special experience in our country
I also have special feelings about being here in Uzbekistan among a
people whose experiences have been similar. I am prepared to talk on
that."

Jean and Jack concurred and our host, apparently satisfied, quickly
set up the portable equipment he had brought with him. In a few
moments he was ready to record. But as he began to pose his ques-
tions it was obvious that he still wanted us to function as instant

commentators on the local scene. At that we balked. It was then that the man decided wholly on his own initiative to turn off his recorder and talk with us off-the-cuff, about those things we felt we could talk about.

Because Stieffelman was a man of intelligence who knew he was not up to date on what Afro-Americans were thinking, feeling, and doing in America, he was quite willing to listen. When he asked about black power, he was told that the most thoughtful black leaders in America recognized the need for the kind of power that would not merely emancipate blacks but also free the very machinery that, even as it oppresses the black man, is moving toward its own destruction.

It was further pointed out that the same conditions binding the Russian and Uzbek peasants against the ruling class during the period of their revolution do not obtain in America. Here divisions between white and nonwhite working peoples have likewise existed for some time, yet no sizable revolutionary coalition similar to that in Europe and Asia is discernible at the moment. We talked informally and freely. As the time for our departure for Samarkand drew closer, Mr. Stieffelman, though he had not made the tape he had originally planned, expressed no disappointment. He commented: "This has been more informative and helpful than I hoped. You have given me a perspective I did not have before, and I thank each of you for it."

There was sincerity in the man's tone and manner and we left him feeling that perhaps we had helped him realize that black militancy does not necessarily fit one mold. We are not all under thirty-five years old and we don't all race hither and yon shouting and screaming indiscriminate obscenities and issuing threats we cannot support. Neither, for that matter, do the more thoughtful and studious among our younger activist brothers and sisters.

I visited a number of museums in Tashkent and I saw and heard a performance at the handsome Tashkent Opera House. As the performers moved about the spacious stage, I took careful note of the

HE DIRECTS TRAFFIC AT A BUSY CORNER

blending of Russian artists with those native to Uzbekistan. And as I scanned the orchestra pit, I discovered not one or two but at least eight women among the musicians. It was a pleasing example of the Soviet claim that their revolution was dealing with the discrimination that had previously barred Uzbeks, and Uzbek women in particular, from full participation in the activities of their country. Throughout his history man has used the arts in bringing about reforms in the structure of his daily life.

That, doubtless, is why, of all the shrines and museums I saw in Tashkent, the one that lingers most persistently in my memory is the Lenin Museum. It was indeed Lenin, the architect of a new post-revolutionary governmental structure, who had been so sensitive to the needs of the non-Russian nationalities who had become members of the union of Soviet states. In one of his many appeals to them, Lenin had directed the following special assurance to the Islamic peoples of whom the Uzbeks are are a part:

Moslems of Russia, the Volga region and the Crimea, Siberia and Turkestan, the Caucusus and Trans-Caucusus—all those whose faith and traditions have been suppressed by the Tsars and oppressors of Russia. From now on your faith and customs, your national and cultural institutions are declared to be free and inviolable. Arrange your national life freely and unmolested. You have a right to it. Remember that your rights, equally as the rights of all the peoples of Russia, are protected by the entire might of the Revolution and its bodies—the Soviets of workers', soldiers', and peasants' deputies.

In view of their former status and what the new order had brought in as a replacement, it requires little imagination to see why Lenin's appeal to the people was (and still is) so positive. And even when and where the practice falls short of the promise, there still exists a profound respect for the planner, Lenin, and those ideals to which he dedicated his life. Surely other nations everywhere else, and I include our own, feel similarly about their founding fathers.

THREE LIBERATED CITIZENS OF SAMARKAND

8

SAMARKAND

WHEN Alexander the Great first saw Samarkand, his astonishment prompted him to exclaim, "I heard that this city was beautiful but I never thought it could be *so* beautiful." The celebrated Greek conqueror had captured the city, then called Maracanda, in 329 B.C., and his assessment of her then must have been entirely correct. In 1970 Samarkand celebrated her twenty-five hundredth birthday. I saw her two years later and she was still beautiful.

No wonder Akram beamed with such undisguised delight as he proceeded to escort us about. He told us proudly: "Samarkand is the place of my birth. Yes, I like Tashkent and because that is where I work I spend a lot of time there. But *this* is the city of my choice. You, too, will love it."

It was hard to imagine as we walked through both "old" and "new" Samarkand that seven and a half centuries earlier the area had been captured and sacked by Genghis Khan. It was not, however, hard to imagine that at the beginning of the fifteenth century Samarkand was the most important economic and cultural center of Central Asia.

The city's geographic position is strategic. Located at the junction of trade routes from China and India, its status as a cultural and economic power was assured even in ancient and medieval times. That its cultural level has long been high was evident to me as I

looked at its old madrasahs (Muslim schools) and other historic architectural shrines.

Samarkand's balmy late autumn climate was in keeping with her beauty and the friendly warmth of her citizens. From a purely pictorial viewpoint I found the latter especially fascinating. To begin with, they were handsome and their good looks varied. Some had fair skins while others ranged from light to deep brown. There were the broad, flat faces of the Mongol as well as the more sharply modeled bone structure of the Persian and the Turk.

Dress was equally varied. While some of the men wore conventional western shoes, trousers, shirts, and jackets along with the traditional Uzbek skullcap, others wore boots, with trousers tucked inside, and long coats held together at the waist by colorful silk sashes. Some of the women favored silk ankle-tight pantaloons of the traditional past, while others preferred skirts, dresses, and silk hose. All wore bright head scarves, and none concealed her beauty beneath a veil. They strode with the self-assurance of emancipated women. Children generally dressed in the manner of their accompanying elders.

A trio of middle-aged men momentarily paused in their late morning tea drinking to look as we approached. They smiled. I went directly to where they had gathered beneath the shade of a tree and extended my hand in greeting. Returning the salutation, one of them promptly emptied the contents of his glass on the ground, quickly refilled, and offered the glass to me. The brew was warm, and green, and aromatic. When I had drained the glass I thanked them in one of the only three Russian phrases I know, shook hands, and proceeded up the street. We had communicated in the universal language of simple good will.

Schoolboys and schoolgirls, seeing one black woman and two black men walking together along their streets, stopped us with the same single-word question. "Africa?" When we responded, "America," they immediately countered with, "Muhammed Ali" and "Angela Davis."

They readily identified with the colorful fighter because of his adoption of their own Islamic faith . . . with Miss Davis because of her avowed United States Communist party membership and what most Soviet citizens regarded as her persecution by United States authorities because of that affiliation.

A quartet of strikingly beautiful college girls accosted Jack O'Dell and me as we walked together in Samarkand. Speaking a few words of English, they joyfully consented to let me photograph them. Their grandmothers wouldn't have *dared*, even though they may well have had the same impulse. How far less inhibited were these young Soviet Uzbek women than even their relatively free Muslim sisters of the Northern Sudan or their devoutly Christian counterparts in Ethiopia!

We continued to walk and then I saw it—the first mendicant I had encountered on this tour. He was an elderly man with an artificial leg that was studiously bared so that passers-by would notice. The man said nothing. But the inverted skullcap he had placed in front of him told the story. I looked carefully at him; he was neither filthy nor did he looked starved. And I noted that though pedestrian traffic was heavy, everyone ignored him.

I later mentioned the beggar to Akram, asking if there were many such people in Samarkand.

"No, but we do have them and they embarrass us because they do not *have* to beg for an existence here. The State provides for them. But they are old and unwilling to give up old habits."

"Are they penalized for begging?" I asked.

"No. That would be fruitless. We simply refuse to encourage them by giving them money. In that way we feel they will soon 'get the message,' as you say in America, and cease the practice. Still, since most of them are too old to take on new ways, we do not hope for too much response from them."

As I listened to Akram I recalled the man, and I thought of him in relation to my neighbors in Mexico who quite regularly made the

rounds as they whined and begged for their daily existence. Many were crippled and they had no artificial limbs. Many were blind and lacked both dark glasses and canes except for those scrounged, and fashioned from makeshift sources. Someone had fitted this old man of Samarkand with a decent substitute for the missing limb. I said no more, preferring, instead, to watch and to wait.

As is characteristic of all Uzbekistan, Samarkand, with its two hundred sixty thousand residents is a silk- and cotton-producing center. Under the Soviets its industries have expanded to include the manufacture of cinema equipment along with automotive and tractor parts. Still, unlike Tashkent, this city is not heavy with the smoke of modern industry. That between 1924 and 1930 it served as the Uzbek capital attests to the validity of its claim to a long and rich *cultural* heritage. That was easily apparent as I observed the local architectural gems of the Timurid dynasty that began with Timur, the Uzbek warrior.

Timur, a spectacular Turkic conqueror, was born in 1336 just fifty miles south of Samarkand. He is said to have been a descendant of

SAMARKAND STREET SCENE, 1973

Genghis Khan, and as one contemplates some of his more bloody conquests, the relationship is easily believed. As a young man he waged successful wars against the khans of eastern Turkistan, as well as Russian and Lithuanian forces at Moscow and Poltava. At forty-seven he began his conquest of Persia and within two years he was in command of its entire eastern portion.

Advancing age was no deterrent to Timur. He was past sixty when he swept over India, leaving Delhi in such a state as to require more than a century of recovery. A fanatical religionist, Timur made a fetish of establishing Islam everywhere he could and of punishing even those of the faith he considered too tolerant of other sects.

Timur was sixty-nine when he set forth on an expedition to China. He never made it. Within three weeks he fell ill and died on January 19, 1405. His corpse was embalmed, placed in an ebony coffin, and buried in an incredibly beautiful tomb at Samarkand called Gur Emir. Never have I seen anything in architecture that surpasses the contour and color of that mausoleum's blue ribbed dome. Seeing it I was aided in my full appreciation of the saying in Samarkand that "Should the sky disappear Gur Emir will replace it."

Nor was Timur the only one to be so honored. The polygamous conqueror himself had ordered a mosque built for Bibi Khanym, his favorite wife. But because of the swiftness with which the ambitiously conceived project was erected under Timur's prodding of the architects, it began to collapse prematurely. The remaining ruins give but a faint suggestion of the size and beauty of the once fabulous Bibi Khanym mosque.

In spite of the massive destruction Timur created in his lifetime, he did also beautify Samarkand with examples of exquisite architecture. Much of it was designed and decorated by artists from lands he had overrun. In all fairness to him it must be said that Timur laid the foundation upon which the cultures of his successors were built. One of the most distinguished of those successors was Ulugbek.

YOUTH AND AGE

It was on a bright, pleasant, November Sunday morning that I was led to the site of the Ulugbek observatory, at its time the largest in the world. The height of the aboveground portion of its marble quadrant (the part used for calculating the height of heavenly bodies) equaled that of Istanbul's Cathedral of Saint Sophia. That section of the observatory no longer exists. Its horizontal circle upon which I stood measured forty-eight meters across, while the underground portion of the quadrant's sweeping concave arc reminded me of a particularly deep and long New York subway escalator.

Ulugbek's catalog of stars was the most complete of its kind at the time it was written. Modern astronomers are impressed by the accuracy of the coordinates of each of the more than a thousand stars listed therein. I was amazed to learn that Ulugbek had calculated the age of the earth within one hour of its actual time. Such was the scholarship of a scientist of Central Asia who lived more than five centuries ago and whose name is barely known to us here in the West!

It is recorded that Ulugbek is the only scholar to have ascended the throne in the history of the Muslim civilization. Grandson of Timur, the despot, he was at once mathematician, astronomer, poet, philosopher, and monarch of his kingdom.

Ironically, it was Ulugbek's superior intelligence that led an ignorant and superstitious assassin to strike him down while on a lonely pilgrimage. "You sought to pry into the secrets of Allah!" the murderer hissed as he plunged the weapon into the scholar's flesh.

The mortal remains were placed in the tomb beside those of Timur. Then the fanatics destroyed the observatory of the renegade among them who dared to gaze at the stars and frighten them with pronouncements they were incapable of understanding. Such is the way of ignorance.

But even as their names are buried, unknown, in the obscurity that is the domain of little men, the name of Ulugbek lives. It lives impres-

sively in Reghistan Square, site of the great Madrasah (hall of learn-
ing) of Samarkand that bears his name. Most madrasahs of the period
were schools of theology. Ulugbek, however, transformed them dur-
ing his regime into schools of scientific study.

Along with scientific advancement, the great Uzbek monarch pro-
moted the cult of civic beauty and commerce. Samarkand became a
city of gardens, palaces, paved streets, and tree-lined avenues. Its
facilities included a good water system, and its iron and silk industries
drew traders from neighboring Persia as well as from distant India
and China.

Such were the innovations that cast Ulugbek in disfavor with those
of his class who lacked his intelligent imagination. The even less en-
lightened populace at large, more conditioned to despotism cloaked in
religious piety than to scholarship, disdained Ulugbek's findings. But
he is reverently remembered today by both scholars and lay people of
Uzbekistan.

Small wonder then that Akram Aminov and our other Soviet Uzbek
hosts, in the spirit of their present way of revolutionary life, would
want us to know what Ulugbek means to them.

It was not long after Ulugbek's tragic death that Samarkand began
to decline. After becoming a part of the emirate of Bukhara, it fell
prey during the seventeenth and eighteenth centuries to the attacks of
nomadic tribes and the Persian empire. Its economy waned. And for
the half century between the 1720s and 1770s it became a ghost city.
A century later czarist Russian troops occupied Samarkand and brought
it under Russian colonial rule.

Samarkand today under the Soviets is a mixture of the old and the
modern. Relics of its past are evident in the architectural treasures
already mentioned, making it a favorite sightseeing place for Euro-
pean and even American tourists. Agricultural expansion has been
advanced by modern irrigation methods which, along with mecha-
nized farming, have increased cotton growth and the production of

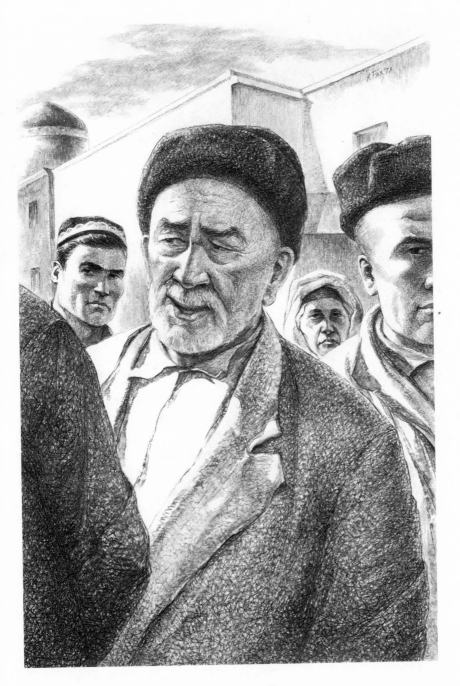

TYPICAL UZBEKS

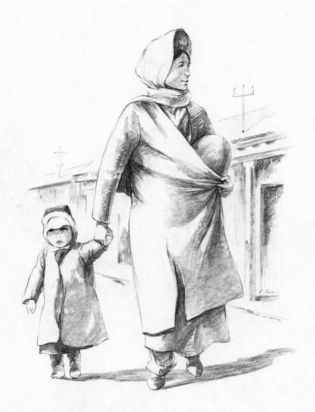

A WOMAN AND HER CHILD HAVE A MELON

cotton goods. Fruit canning, wine making, karakul breeding, tea, leatherware, and tobacco are also associated with Samarkand's agriculture. Superphosphates and the manufacture of machine parts contribute to its industry.

Still, Soviet Samarkand's university, medical school, and other institutions of higher learning, serving thirty thousand, make it essentially a center of culture. It is still a city gently haunted by the spirit of King Ulugbek, the scholar, who dared gaze at the stars and then pass his findings on to those who lacked vision. I never ceased to feel the great presence as I strolled along the sidewalks and scurried over the city's crosswalks out of the way of the constantly moving motor traffic.

The one thing about this city I remember so well is the alertness of

its people and their particular desire to communicate with Jean, Jack, and me. That it is the greatest educational center of the Uzbek republic does in part account for the intellectual curiosity I found there. Recalling that in the capital city of Tashkent we had noticed how the huge photograph of Angela Davis dominated the entrance room of the Poineer Youth Center, I had concluded that once outside that big city I would find no similar interest in her anywhere else in Uzbekistan. Certainly it seemed fitting that the International Friendship Club of the Youth Center would be conscious of Angela, and that I felt would be the extent of that. I was mistaken.

Uzbek teen-age boys and girls on their way to and from school in Samarkand clustered about us talking excitedly in their own tongue. When we indicated we were American, they grinned and exclaimed, "Angela Davis!" A few raised their fists in the familiar black power salute. I whipped out a small sketch pad and motioned to one especially friendly girl that I wanted to sketch her profile. Friends of hers gathered around me, looking alternately at her and at the emerging likeness. When I finished the sketch and handed it to the child, she was speechless for a moment. She then thanked me, first in Uzbek, then in Russian, and finally in English. We shook hands and I moved along down the street.

A pair of boys on a bicycle shouted in my direction, "Muhammed Ali!" I waved in return. The one on the back dismounted and motioned for me to take his place. I thanked them both in Russian (one of the three expressions in that language I am not fearful of using) and adroitly disappeared in the sidewalk crowd. And later, at a teahouse over lamb shish kebab, Uzbek bread, and green tea, I roared with laughter as the two young Uzbek men at the next table tapped open palms, soul-brother fashion, in mutual approval of something one had said.

John Sutton had been so right. The Uzbeks were, indeed, startlingly like "our folks."

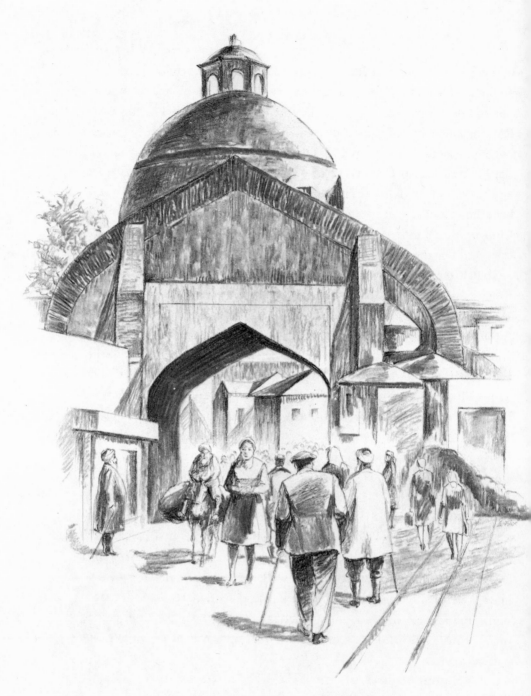

BUKHARA—OLD AND NEW

9

BUKHARA

ALL OVER Ubekistan it is known as "white gold," and I could not help
but be aware of its mighty presence everywhere I went. The huge,
neatly squared-off mounds of freshly picked cotton I had seen on the
outskirts of Tashkent were abundant likewise near Bukhara. It is in
this Central Asian Uzbek city that much of the region's precious crop
is ginned. The big harvest had taken place shortly before our arrival.
And even though much of the Tashkent-made farm equipment had
been put to good use, the bulk of the soft fluffy fruit had to be tedi-
ously hand-picked, boll by boll. Looking at those tons upon tons of
Soviet cotton grown in Uzbekistan took me back forty years and thou-
sands of miles to a scene I had known in rural South Carolina.

The Depression was on, and our family of four shared the small,
unpainted, clapboard house of my wife's aunt and her husband. Two
very old women and two minor girls shared the same meager home.
Isaac Scriven, the head of the house, was all-man. Wiry, very black,
and of medium build, he was then a very hardy sixty-year-old. He
worked from dawn to twilight five days each week and till noon on
Saturdays. On that afternoon he would drive his old Ford to town
nine miles away. Sunday was his day of complete rest.

Sometimes I worked with him, cutting wood logs for firewood.
Though I was considerably younger, he was a more skillful woods-

man. He taught me how to use my strength sparingly and how to keep from splitting my foot with the axe. This man, with little formal education, was endowed with an enviable integrity, intelligence, and pride. He was soft spoken and very gentle. But seeing how frequently he oiled his two guns and kept them loaded and ready made me realize why nobody ever crossed him.

Though poor in material goods, he tilled his own small plot of cotton-producing land and he was in debt to no one. He owned a cow, a mule, a half dozen hogs, a few chickens, and the house he lived in and had built with his own hands. In that regard he was far better off than many neighbors who sharecropped or third-cropped on white folks' land. At the end of the cotton harvest they were to share either one third or one half of what they had earned. But it never worked out that way. By the time the thieving "cracker" owners got through adding up the various "charges" to their illiterate tenant farmers, the latter might easily find themselves hopelessly in debt. In that respect their plight closely resembled that of the unorganized Uganda farmers I mentioned in the preceding section of this book.

Among our black neighbors the Reverend Moses Jackson was another of the exceptions. Pastor of the little Ebenezer Presbyterian Church, his house and land were bigger and more opulent than Isaac Scriven's. The neighboring white "cracker" landlords weren't too fond of Jackson, for while not vocally militant, he was too prosperous and independent for their tastes. But they had no cause to seize and flog him, as was their custom with "uppity niggers."

I vividly remember the Saturday morning the Jackson home caught fire. Just how it happened nobody knew, for there was no one at home at the time. I heard the men shouting and running toward the house just across the road; and as I ran outside and saw the flames shooting from its upper windows, I knew the elegant old frame house was doomed.

Joining the other men I rushed over the porch and inside the parlor

as the flames roared overhead. We seized the upright piano and whatever else we could and staggered out with them. Someone shouted, "Let's get Rev's cotton before the wind carries the fire to the barn!" Not until that moment had I known how precious cotton was to every farmer who grows it. Nor did I realize how easily a few desperate men can pick up bales of it and *run* it to safety. With the cracker farmers watching happily from the sidelines, we black men saved the cotton and a few articles of furniture. The house, except for the smoked chimney, went right to the ground in a heap of gray and glowing ashes.

A few weeks later I rode with Isaac atop his mule-drawn wagon as he took his cotton to the gin. The sharecroppers and third-croppers were there too and we knew, as they did, that they would later be robbed deaf, dumb, and crippled by their greedy landlords. That was forty years ago. Such conditions still exist among the tenant farmers and "croppers" of our rural South.

I remembered what I had seen and lived through. I, too, had miraculously escaped injury when, upon discovering that Isaac Scriven's dry shingle roof had been ignited by chimney sparks, I had managed with the help of neighbors to extinguish the fire before it got ahead of us. And along with the looks of sadistic satisfaction on the faces of the white farmers watching Jackson's house burn to the ground, I recalled teaching at Claflin College, fifty miles away in Orangeburg. There the specter of heavily armed red-neck policemen recently shooting to death three unarmed black students, while they injured thirty-four others on the campus of State College just a few yards from where I used to hold my classes, still stalks the memory. Racist acts of terror are not yet dead in America, North or South.

All of this rushed into my consciousness at the sight of the cotton outside Bukhara. But my anxieties were calmed as I recalled what Langston Hughes had been told in Uzbekistan. Said an Uzbek cotton worker to him of the new order of things since the Revolution:

Before, there were no schools for Uzbek children—now there are. Before, we lived in debt and fear—now we are free. Before, women were bought and sold—now no more. Before, the land and water belonged to the beys— today they are ours—and we share the cotton.

Even more recently Hedrick Smith, writing from Samarkand in *The New York Times* for November 11, 1972, reported on the cotton harvest I had seen there the previous year. He had observed that the harvest had been made by "thousands of city people reinforcing peasants." Teachers, university students, white- and blue-collar workers and even schoolchildren from the fifth grade up worked with the farm people. Most of the seven thousand students of the Bukhara Pedagogical Institute joined in the work, closing the school from October 1 until past the middle of November.

The extra pickers earned five kopecks a kilogram, which amounts to six cents for two pounds of cotton picked off the plant. For that which they retrieved from the ground and cleaned, they received eight kopecks. So the university-level teacher of literature, who picked two hundred pounds in one day, was not as concerned with earning the "extra" equivalent of six dollars. His concern was with what he had been able to accomplish for his nation.

What I was witnessing, therefore, here in those huge stacks of hand-picked cotton, represented a pride in their way of life. And in the light of my own personal experience, I am not ashamed to say that what I saw in those squared-off hills of cotton in Uzbekistan and what I knew they symbolized pleased me. I had been witness to, and for a spell, part of, a far less inspired similar performance in my own land.

My first view of Bukhara itself told me that it was a city of great antiquity. Though its exact age is unknown, many historians believe it to be older than neighboring Samarkand. The ancient landmarks I saw in Bukhara certainly pointed toward that probability. Both ancient Samarkand and the territory that is now modern Bukhara were conquered by Alexander the Great. There followed a succession of

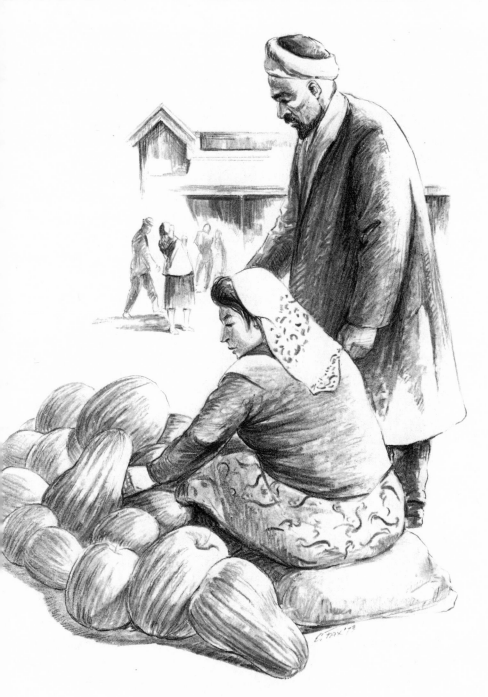

SEEN IN THE MARKET AT BUKHARA

occupations by Turks and Persians, during which Bukhara, under the Samanid family, became a tenth-century center of learning. Then, along with Samarkand, Bukhara was sacked by the Mongol hordes of Genghis Khan. Persia regained control, and by the eighteenth century Islam was firmly established.

During the eighteen hundreds Great Britain and Russia vied for possession of Bukhara. Each sought to ease its way into the area through emissaries they sent to Emir Nasrulla. But crafty Nasrulla, a rascal in his own right, received them with smiles and promptly liquidated two of the Englishmen. The grim implications of that episode were by no means lost on the Russians.

Twenty-four years later, 1866 to be exact, the Russians returned with an invading army that came down so hard on the emir he was forced, a couple of years later, to declare himself a vassal of the czar. He was even moved to throw the not inconsiderable weight of his support to the protecion of Russian trade.

The resultant situation provided no easy roadway for the plain people of Bukhara. Under pressure from their new Russian czarist masters as well as their fawning emir, who was pledged to hold the masses in line for the czar, they were ripe for rebellion. Meanwhile, the Revolution in Russia was building to a crescendo. Within two generations the emir was overthrown and Bukhara was declared a Soviet Socialist Republic.

Bukhara, as I saw it, presented a picture of the medieval blended with the modern. If anything, the emphasis may have been a bit more on the medieval than in Samarkand. Its one hundred twenty thousand mostly Uzbek inhabitants included a number of Afghans, Arabs, and Jews. Some, of obvious Mongolian ancestry, attired in the garb of their forebears, looked as though they had only recently left their yurts on the barren mountain wastes.

Others, of decidedly brown complexion, resembled desert nomads. Still others, except for the Uzbek skullcap and the silk head scarf,

A MOTHER AND DAUGHTER AT BUKHARA

could pass quite unnoticed along Mexico City's Paseo de La Reforma, or through New York's Puerto Rican community.

I became conscious as I looked about me of the huge billboard-size portraits of Lenin at various points about the city. And I wondered what messages were being conveyed by the imposingly displayed slogans adorning the facades of public buildings. There was one directly over the entrance to our hotel. It was lettered in Russian.

We asked shapely, bleached-blonde Tamara, one of our official guides in Bukhara, to translate it for us. "It says - HOLD HIGH THE BANNER OF INTERNATIONALISM," she responded. Quickly recalling something I had read about Lenin's views on internationalism, I could understand what motivated him to promote his concept of it nearly seventy years ago. How conscientiously internationalism may or may not be practiced today in Uzbekistan and other Soviet republics is not what I seek to show here. I do, however, think it important to capsule briefly what precipitated Lenin's advocating it.

There were well over sixty nations, national groups, and minorities in Russia prior to the revolution. Their numbers totaled one hundred and seventy million, of whom one hundred million were non-Russians. Lenin believed they could retain their own national identities and still consolidate to form one big union of Soviet states. To achieve that he was stubborn in his resolve that no ruling class in any national group should be allowed to misuse its working class for selfish, gain under the guise of preserving national unity and national self-determination.

Lenin knew how difficult that goal would be to attain. He was fully aware of the many temptations nagging men who hold power over other men. So he constantly reiterated his revolutionary aims. His present-day successors, following both the principles and some of the techniques of their mentor, find it advisable to make public use of his sagest slogans, such as I saw in Bukhara.

At another point in that ancient city my attention was drawn to an impressive tower of extraordinary beauty. It was the Minaret Kalyan,

SHE SUPERVISES AT THE EMBROIDERY HOUSE

a massive one-hundred-and-fifty-two-foot monument erected in the twelfth century. The chilling legend that criminals sentenced to death were once tossed from its uppermost windows substantiates the knowledge that medieval forms of punishment for crime were (and still are) inordinately cruel and senseless.

A less spectacular sight, but one productive of information pertinent to a local industry, awaited at the factory where gold thread is used in the making of fancy embroidered items of apparel. Inside the large, quiet, airy room, I observed workers busy at their daily tasks. Among the things they were making were the Muslim caps worn by both men and women. While many were machine-stitched and embroidered, the first were handmade.

Most of the several dozen workers were women. I looked at them as I moved slowly from one table to the next. Many appeared to be past thirty years old. Those who operated machines did so with the matter-of-fact dexterity of factory workers everywhere. It was amazing, nevertheless, to note how beautifully the machines simulated the stitches of the embroiderer's hand.

Those who worked solely by hand drew high praise from me. I regard fine craftsmanship as an art form. And it was interesting to note that those hand craftsmen using the precious gold were careful not to embroider all the way to the reverse side as with the regular silk. In that way they conserved the valuable metal thread.

The plump, smooth-skinned Uzbek lady in charge of the group was a pleasant and willing hostess. Not only did she encourage us to look about but through an interpreter she answered all our questions. She informed us that the plant had been established after the Revolution. Those who desire to learn the craft come in as early as age eighteen, as she herself had done.

They work a five-day week, eight hours each day, she told us, and at the end of the first eleven months of employment each worker is entitled to a paid vacation of eighteen days. Salaries range from 120

to 150 rubles each month (or slightly more than $120 to $150), and all medical expenses and similar benefits are borne by the state. Rents are very low, and day centers provided by the state look after the children of the workers. They looked reasonably healthy and seemed no more or less happy than factory workers I have seen in America.

By contrast the open marketplace was colorful, lively, and almost (but not quite) as intriguing to me as the nearby traditional teahouse. There I learned that really to enjoy Uzbekistan tea with lamb shish kebab and Middle-East bread, one first mounts the stairs to the outside verandah overlooking the street. Then one seats himself cross-

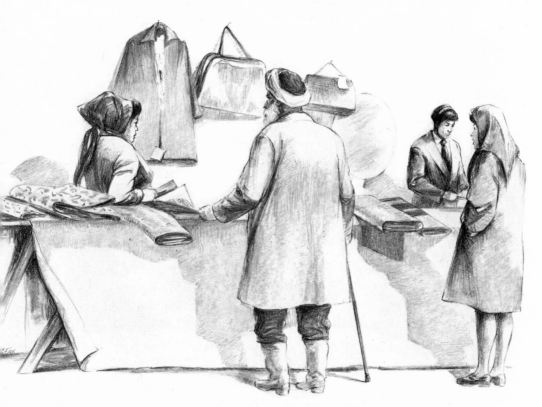

THEY DISPLAY THEIR WARES ALONG THE WALL

legged before the short-legged table and delights in his refreshment while taking in the sights around him.

It was while sitting in such a place in Bukhara that an elderly man approached us, soliciting alms. That was our second such experience in Uzbekistan. Scarcely had he begun to whine in his native tongue than a younger man from the neighboring table rose, quickly walked to the old man's side, and gently led him off. He then returned to our table and graciously offered apology for the intrusion. I cannot recall a similar resolution of the same situation as I have encountered it in Latin America and Africa, not to mention sections of New York City and even Washington, D.C.!

Modern Bukhara, with its growing light industry buttressed by the recent discovery of natural gas deposits, still clings to aspects of her ancient past. It is just that linking of past and present that Lenin had in mind as he defined the spirit of Soviet internationalism. So while the former prestige of the old theological madrasahs has given ground to the Ulugbek concept of what a school should mean to Uzbek people at large, the ancient edifices themselves remain. They do no harm.

Indeed the handsome tenth-century mausoleum of Ismail Samani stays, as do other relics of the days of the emirs and the khans, to remind Uzbeks of that which must never return. In one of them I found a reason for both the success and the failure of czarist colonialism in Bukhara.

It was a late nineteenth- to early twentieth-century emir's palace that has been retained as a museum. Before entering we were required to remove our shoes and wear the soft slippers provided at the door. The main entrance just off the inner courtyard led into the most sumptuous and ornate rooms I have ever seen anywhere. The carved walls and ceilings resembled frosty lacework. Huge and expensive Chinese vases stood imposingly in the corners of the room, which was tastefully filled with furniture handcarved from the finest Eastern woods. And the rich floor carpetings whispered underfoot that they

had never been loomed to be trod upon by a mere peasant like me.

Silk wall hangings vied with the emir's personal effects, carefully encased behind glass. I looked at the jewelry. The luscious emerald, ruby, and sapphire stones winked in the sunlight. One item caught and held my attention. It was the ornate belt once worn by the chief occupant of this modern palace of another age. The belt's enormous length suggested that such girth of the wearer could be achieved through only one means. Gluttonous eating.

The sight of such decadent symbols of the overindulgence of the favored few at the expense of the many became a mute reminder of why the emirs and khans became the willing tools of the czars. They also testified clearly why the emirs and khans later fell before the guns of the hungry and incensed revolutionary have-nots.

A REFRESHMENT STAND IN FERGHANA

10

FERGHANA

OFTEN referred to as "The Pearl of the Soviet Union," Ferghana is a young city. That is apparent as soon as one enters it. Ferghana has a shiny, new, modern look. Founded in 1877, it became the capital of the province of Ferghana, created from the former khanate of Kokand. Until 1907 it was called Novy Margelan, but between 1907 and 1924 was renamed Skobelev. Since then the city's rapid growth has been attributable primarily to Soviet ingenuity.

Today Ferghana is a city of one hundred ten thousand. In addition to its agricultural output in cotton and the cultivation of silk, its industries combine silk and cotton textile manufacture. Though Ferghana's oil refinery is Central Asia's largest, I was not made conscious there, as in Tashkent, of heavy air pollution.

Driving into the city from the airport we passed along paved boulevards whose neatly rowed trees were whitewashed as a deterrent to destructive crawling insects. Buildings, shiny, modern, and often surrounded by flower beds, lined the avenues. Downtown Ferghana was so clean and rich in vegetation as to appear more like a huge botanical garden than a small bustling city.

Away from the heart of the business activity, however, I saw the rows of older, gray, but still neat adobe dwellings. These were the homes of inhabitants not yet accommodated by the new, swiftly rising

housing projects. I noticed that most of the adobe homes had been painted with kalsomine, as they frequently are in Mexican towns and pueblos.

But their lacks were by no means reflected in the attitudes of those who lived in them. Though I was later to walk slowly among the residents of the area, not once was I accosted by a peddler or a beggar.

Akram Aminov was with us on that initial trip into and around Ferghana. He was joined by a personable young local man who worked as an official guide. Neatly attired in a dark business suit, and not as swarthy as Akram, the young guide's dark hair and eyes beneath the Muslim skullcap proclaimed him a true son of Uzbekistan. I complimented him upon the ease with which he spoke English, and I detected the pride in his pleasant reply that he was equally fluent in Russian and his native Uzbek.

"I was a teacher in the primary schools here before becoming involved with this work. And I like this better because not only do I meet so many interesting people but I get a chance to learn more English."

He grinned, and I suspected that he also earned more money as a government guide. As we reached an apparently new housing development rising four or five stories high, I asked about the cost of rental.

"They rent from one to three, perhaps four rubles each month," was his reply.

The apartments were modern, with hot and cold running water, individual bathrooms, and electricity. A few TV antennae were visible and I was told that all occupants had radios. I recalled the young Tashkent woman who had talked with us only a few days previously and had pointed out her own apartment in that city. Her monthly rent, too, did not exceed three or four rubles. Clothing and shoes, however, were not cheap, though food costs, I was assured, were not

excessive. So with rent consuming little more than a tiny percentage of the monthly wage, and health care and education costs provided by the state, the factory worker earning 120 to 150 rubles each month could manage adequately.

As I looked at our hosts I observed that while they made no pretense at being fancily dressed, neither were they threadbare or emaciated. And the one thing I noted above all else was that they seemed to harbor few illusions of grandeur. None was driving an expensive car. None made any allusions to luxury items for which he had plunged into heavy debt. Small wonder then that these working people with whom we met gave no manifestation of the many symptoms of desperation so common to those obliged to claw and elbow their way from one pay envelope to the next.

I looked at the people as they passed by along Ferghana's streets. They were sturdy, apparently well fed, and handsome. As if in keeping with the newness of their city, many of the younger men wore slacks, sweaters, and jackets, while the young women wore knee-length skirts with blouses, or tailored suits. Older men favored the traditional trousers tucked into knee-length boots with robes tied in the middle by silk sashes. A few of the older women preferred the local and colorful silk dresses and head scarves. And in the tradition of the past, several automatically drew scarves across the lower part of their faces upon approaching a stranger.

The distinctive multicolored silks glimmered in the morning sun. As we noted the rows upon rows of mulberry trees lining many of the streets, I was reminded that their leaves fed the worms whose spinning provided Ferghana with one of its main industries. Indeed, we were en route to the famed Margilan Silk Mill just outside the city. Meanwhile, Akram and our former schoolteacher guide were eagerly briefing us on our immediate surroundings.

"This is harsh land, they began. Though it is rich in oil, the soil needs constant rejuvenation if it is to continue to yield cotton, our

MULBERRY TREES IN LATE AUTUMN

major crop. So we use nitrogen and we do rotation planting to aid in our struggle to keep it fertile."

Akram pointed out that 60 percent of the Uzbek region is desert, 20 percent is mountain, and most of the remaining 20 percent is steppe. He reminded us that the Soviets, in contrast to the feudal land barons of prerevolutionary days, have done much to advance the agricultural development of the Uzbek land.

"In my own thirty-nine years of life I have already seen quite a bit of the desert reclaimed. And we shall reclaim even more. Even now we produce 72 percent of the cotton used in the USSR. And with our factories we produce a lot of natural and *snythetic* silks for export to the foreign market."

We had arrived at the Margilan Silk Mill. Our first stop inside was at the noisiest section, where raw silk was being spun into thread. The wheels of machines, manufactured in Tashkent, whirred and rotated under the constant scrutiny of their operators. Uzbek men and women alike worked mutely since the perpetual clatter of vibrating machines rendered conversation impossible. I learned that these workers put in a shorter week and received extra compensation for the hazards to hearing and the nervous system.

From the roughest areas of the production of silk fabric we moved through other departments into the spacious printing room. There on the tables, measuring 120 meters in length, the woven cloth passed beneath many silk screens until the final color was applied. A part of that process was done by hand, but most of it was mechanically completed.

My final stop in the working section at the Margilan Silk Mill was the art department. Small, light, and airy, with workers numbering not more than six. These were the plant's elite, responsible for the designs and patterns that would be seen in the silks worn from Central Asia throughout areas of Europe.

Five were women—four Uzbek, one Japanese. Their chief was a

serious blue-eyed Russian man who had served for twenty years as the mill's number-one designer. A measure of the esteem in which he was held by the five women who worked under his direction was seen in their pleasure as I made a quick life-size profile of him and presented it to the department.

We had seen an informative process at the Margilan Mill that produces twenty-five million meters of silk each year. Moreover, I learned before leaving what the presence of three black American visitors had actually meant there. It first made itself clear to us when one young, brown, Uzbek woman left her table and followed us quietly through her department. As we were about to leave that room she approached and began to speak. Our translator promptly relayed what she was saying.

"Please tell the black visitors from America that we are so happy to have them here with us this day. We Uzbeks understand well what their struggle to be free human beings really means."

She then offered her small pair of scissors. "It is all I have to offer as a gift of our friendship. But I offer it in sincerity."

We thanked her and I asked if she would let me make a quick profile sketch of her. She did, and when it was signed I offered it to her with our sincere good wishes. Through those brief moments poured a human experience common to both our peoples. They, who only two generations past had been scornfully called "yellow dogs" by racist czarist oppressors, felt an empathy for us who know the sting of "nigger." No more needed to be said between us.

That small vignette set the perfect tone for the unexpected treat that followed. In Central Asia drinking tea with another symbolizes friendship, and we were being invited to tea in the silk mill's own dining hall. Never in my life have I partaken of a more sumptuous "tea."

Two varieties of melon, watermelon, and an incredibly fragrant muskmelon started us off. There were grapes, a long and sweet variety

called "devils' fingers" by the Uzbeks. Almonds and pistachios locally grown, and a fig juice completed the appetizers. Then came the soup of lamb and vegetables. All was eaten in the most leisurely manner. The main course consisted of beef, lamb, and fresh vegetables, and there was plenty of everything. Wine and vodka helped stimulate conversation.

"We have noticed that you have not asked us the questions normally posed by Americans who tour this area. We understand and appreciate the sensitivity you show in not asking questions designed to annoy rather than to elicit information." It was Akram, our poet-host from Samarkand, who spoke. As a polite and sensitive man, it was obvious that he and his Uzbek colleagues with whom we had been associating would value good manners. After all, few of us would feel kindly toward invited guests who, while enjoying our hospitality, would insist that we describe our family squabbles and troubles to them. All families everywhere have problems that embarrass them and they don't appreciate being heckled about them—especially by those they have invited in from outside. Akram spoke again.

"Because of your understanding what we are doing here, today is more than the 'official reception' accorded visitors from abroad. Our greeting to you is one reserved for friends and family. So we break our bread with you in friendship."

With that, Akram broke the delicious disks of bread and passed a piece to each of us. And we continued to eat and to talk for two hours. It was a memorable occasion, that visit to the Margilan Silk Mill. From there we concluded our day in Ferghana with a trip to a nearby collective farm.

Because it was late November, farm activity was minimal. I did, however, meet the Uzbek chairman and vice-chairman of the project, along with a lively and devilish local poet named Khamdamov. Through interpreters we talked and joked while I made sketches of

A COLLECTIVE FARMER OUTSIDE FERGHANA

each of our hosts. They were all family men, with Khamdamov, the father of nine, leading the others in that department.

Again we were invited to break bread. That meal, quite as formidable as the earlier "tea," was concluded with the serving of a native dish of warm spiced rice mixed with lamb and eaten directly from the huge serving plate with the fingers of the right hand. And of course there were the bowls of famed green Uzbekistan tea. On the following day we would be flying north to Leningrad, our brief but exciting visit to ancient Uzbekistan over for the time being.

I put it that way because I feel I should return a bit later to see what has taken place in the interim. Remarkable changes for the better have come there to a people who, until recently, were the economic and social pariahs in their own land. I want to see how much further the Soviet promise of equality and internationalism for Uzbekistan has moved toward the fruition of the internationalist ideals expressed by Lenin.

I had observed, communicated with, and thoroughly enjoyed myself with these Uzbek folk. Barely sixty years ago their grandparents, parents, and a few of them had been subjected to the racist indignities many of us in America, *blacks and other nonwhites*, know well. They had been reviled, spat upon, and herded into unpleasant places designated just for them. They too had been the last hired and first fired from any other than the meanest and lowest paying labor. The Uzbeks are close to that past. Yet such blatant injustices as I have just described were not readily visible to me as I observed and talked with them.

How could I, in so brief a time, be sure that the thing I saw in them, in their faces and postures, was a genuine dignity and not merely a pose? I was sure because I have seen the same thing among those of my own people who have managed, in spite of the pressures they endure, to find their own liberation. It has certainly not been a complete liberation. Indeed it was often just a state of mind that could not actually liberate them from the physical fact of the night

rider, the hooded klansman, or even the lyncher's rope and torch.

But it was a liberation from the *paralyzing fear* of those things and the accompanying conviction that such horrors were an inevitable and permanent condition. It was such liberation that enveloped and held Rosa Parks on that memorable December 1, 1955, when she made up her mind that she would ride on any part of that jim-crow Montgomery, Alabama, bus she damned well chose. Her personal liberation of that moment set in motion a whole new revolutionary movement, of which Martin Luther King, Jr. became the spiritual leader.

That movement flashed briefly before me as I sat with our hosts at Ferghana's Margilan Silk Mill. I could see the "new look" along the liberated blacks of the South who had survived the beatings and hosings, so that life would be better for all Americans. And though we are not yet as liberated as a people or as a nation as we shall be, the new image will not be wished away by those who fear it. It was that same new image that radiated from our Uzbek hosts, whose transformation has been even more spectacular than our own. They could not fake such a thing and thus deceive me, for we too have walked the same path for three and a half centuries.

I have been asked how I would regard what has transpired over the past sixty years with the Uzbek people in comparison with what has transpired among our own American minorities whose rights as citizens and human beings have been violated over the past two centuries. In consideration of time and resources alone, I feel that as far as advancement of the interests of people at large is concerned the edge belongs to the Soviet Uzbeks.

Does that mean I think our minorities have inherited all the ills of an evil society, while theirs have fallen heir to all the healthy benefits of a perfect one? Not at all. I am aware of those strong and constructive forces here in America. And I have been quite frankly told by at least one of my Soviet hosts that they too are plagued constantly by

problems they will have to solve. I can well believe that.

Would I want to abandon America to live permanently in Uzbek-istan? Certainly not. Had I been asked that question there, as I was asked it in East Africa, I would still say "no" and for the same reasons, with this one addition. I believe America will soon have to choose between being what it says it is or taking a place in history with other former world powers who have fallen amid the debris of their own immorality. The youngest heirs among us deserve better than that. I want to be around to help this nation "get it together" and be what millions of us know it can be.

EPILOGUE

AMERICA, East Africa, and Uzbekistan, USSR—three distinct areas of the world that seemingly share little in common. Yet in retrospect I can relate what I, an American, absorbed from my visits to the latter two places. My conclusions seem to me by no means unreasonable, for the broad parallels are, in purely historic terms, visible for all to see.

I have already designated why, in the face of what I saw and heard in East Africa, I conclude that the nations mentioned are not truly free and independent. The same, of course, may be said of other nations on other continents. But it is specifically to four East African countries that I have devoted the first portion of this book. Moreover, as I think about it, I am reminded that with modifications the same human condition I observed among many East Africans obtains elsewhere. Our own country is not excepted.

In spite of the tremendous industrial, technological, and material attainments of this most powerful of the world's nations, we are still faced with a troublesome and nagging truth. Economic, political, and social independence, along with equality before the law, simply are not attained by the poor, by nonwhite minorities, by the aged, or by women here in America.

And even as that sad fact persists, there is no scarcity of assurances and reassurances that "all is well." The carefully repeated clichés

about our national freedoms and system of justice for all under the Constitution and Bill of Rights are at odds with the facts.

Ask any honest and thinking American Indian. He will set the record straight for you. So will any free-thinking poor white, once he discovers that it really isn't the "niggers, greasers, spics or gooks" who have deprived him of gainful employment and reduces his family to the dole.

Or how about asking that attractive woman, who incidentally is favored to outlive you if you are a man. Ask her what it is like to be denied certain types of employment for which she has every qualification except that of gender. Take a few moments to listen to that young and articulate writer, Frank Chin, who lives and works in San Francisco's Chinatown. He will swiftly clarify all that nonsense about the "exotic quaintness" of the unpleasant aspects of the ghetto he and others know so dreadfully well. All of the aforementioned share the common experience of having their human rights abridged and their dignity affronted. They are neither isolated nor alone.

East Africans decrying "flag independence" as a pernicious substitute for the real thing are embroiled in another facet of the same injustice. So one wonders if the skilled native Ugandan, denied adequate compensation for his work, is really far removed from the similarly positioned American Indian. Those American reporters critical of restive Ugandan attitudes would do well to examine carefully our own domestic inequities before rushing into print to condemn outraged Uganda nationals as "black racists." And while it may be easy, because of American racist feelings, to convince impoverished Appalachian whites that they are better off than poor Ethiopians, the hunger each endures hurts in the same places.

And Uzbekistan? As I contemplate it, I relate what I have studied of her past to what I have learned of America's early experience. Uzbekistan had its colonial czars; the American colonies, their British monarchs. The czarist racist attitudes toward Uzbeks paralleled those

of colonial settlers toward the indigenous Indians and the imported African slaves.

With the passage of time came modifications and changes. In America at least there were modifications and changes of racist *tactics* rather than of racist attitudes. I know, for I have lived through them. Just how true are the rumors of current racism in Soviet Asia, as reported in certain segments of the American press, I do not know. My stay in Uzbekistan gave me only the brief look I have honestly reported—nothing more. But this I do know.

If it is true, as her severest Western critics insist, that in spite of the prodigious Soviet strides in raising the level of human existence in Uzbekistan, they are denying Uzbeks a just share of their human rights, America can derive small satisfaction from such allegations of Soviet failure. If the presence of those Russian technicians and advisors I saw in Uzbekistan means that they believe Uzbeks "ain't ready yet," I am thoroughly familiar with the theme. It is still being used here by defensive men who have deliberately prevented other men from getting ready.

And if every positive thing I saw in Uzbekistan was rigged solely for my consumption (a highly unlikely circumstance), I would, as an American still loyal to those principles of justice and equality for all upon which this country was founded, feel obligated first to help set our own house in order. Achieving that would constitute a service far more meaningful to America and to mankind at large than the diversionary tactic of pointing to the disorder in our neighbors' houses. Admittedly it would be a more arduous task. Hard work at self-improvement is rarely a popularly accepted pursuit.

Ours is a young nation on the threshold of its two hundredth birthday. Its indigenous inhabitants, older than the nation itself, have been badly treated, nearly to the point of extinction. The peoples of both East Africa and Uzbekistan are likewise older than their respective nations, and in spite of their mistreatment, they have survived. But it

is the USA and the USSR (the latter not yet sixty years old) who hold the first and second positions respectively in today's world. Their rapid industrial and military rise, particularly that of the Soviets, has been nothing less than phenomenal. Because of their positions, comparisons between, and speculations upon, the two are inevitable. Can only one system survive or can both coexist? I cannot prophesy.

But in my judgment the real test of any government's staying power is the degree to which it succeeds or fails in capturing and holding the respect and the confidence of those it governs and serves. It matters little what name tag that government wears. Its leaders are held responsible to their people. History has made that truth abundantly clear.

INDEX

Abdullah, Mohammed Ahmad ibn as-Sayyid, 39–40
Abdullahi, Khalifa, 40
Addis Ababa, Ethiopia, 59, 61, 68–72, 76–80
Adigrat, Ethiopia, 62
Africa
 colonialism in, 3–4, 10, 12
 See also East Africa
Africa Day, 98, 101, 102
African-American Institute, 52
Aga Khan, 92
Aksum kingdom, 60–61
Alexander the Great, 134, 157, 172
Alston, Charles, 54
Amhara, 59, 60
Amin, Idi, 10, 21
Aminov, Akram, 141–42, 143, 157, 159, 164, 184, 185, 187, 189
Andrews, Benny, 48
Arabs
 in Northern Sudan, 36–38, 46, 52
 in Tanzania, 90, 94, 103
 Uzbekistan and, 134
Asmara, Ethiopia, 58, 59, 61, 62

Baghdadi, Bastawi, 46
Baldwin, James, 48, 150
Bantu, 90
Barclay's Bank (Kampala), 33
Bearden, Romare, 48, 50
Benrji, Mr., 92–93
Berlin Conference, 3, 12
Biggers, John, 81–82
Birdland, 82
Black And Beautiful (drawings), 122
Bond, Jean, 105, 113, 115, 141, 148, 151, 152, 167
Boronetsky, Mr., 121
British East Africa Company, 12
British East India Trading Company, 15
Brooks, Wendell, 64–65
Browne, Mr., 61–62, 65, 67
Buganda, 10, 12
Buganda tribe, 9
Bukhara, Uzbekistan, 4, 136, 137, 164, 169–81
Burton, Sir Richard, 88

Carver, George W., 132, 134

"Chalk talks," 6
Charles, Ray, 48
Chin, Frank, 195
Christian Coptic Church, 1
Civil rights, 6
Claflin College (South Carolina), 171
Clarke, John Henrik, 52, 54
Cleaver, Eldridge, 48
Cobb, Charlie, 32
Colonialism, 3–4
Coltrane, John, 48
Crichton, Mr., 26–27
Cushites, 59

Dar es Salaam, Tanzania, 88, 89–97
Davis, Angela, 146, 148, 158, 159, 167
Davis, Miles, 48, 56
Davis, William B., 70–71, 72
Dawson, Horace, 24, 25, 26, 29, 30, 32
Dekhterev, Boris, 121
Dire Dawa, Ethiopia, 75–76
Dresdova, Nina, 121
Drury, Harriet, 96
Du Bois, W. E. B., 150

East Africa, 1, 4, 5, 6, 107–108, 194–95, 196
 industrialization, 12
 See also Ethiopia; Sudan; Tanzania; Uganda
East Africa Company, see British East Africa Company
Edison, Thomas A., 133
Elliott, James N., 73
Ellison, Ralph, 150
Entebee, Uganda, 12
Ethiopia, 1, 57–85
 history, 60–61, 68
 people, 59

population, 59
women in, 70, 74–75

Ferghana, Uzbekistan, 183–93
Film making, 150–51
Firestone Rubber Company, 46
Fort Portal, Uganda, 29–30
Franklin, Aretha, 48
Freedomways (magazine), 7
Fromentius, Saint, 61

Galla, 60, 61
Garnett, Norris, 89, 90, 92, 118–19, 121
Garvey, Marcus, 7
Genghis Khan, 3, 134, 157, 161, 174
German East Africa Company, 88
Ghana, 46
Gondar, Ethiopia, 61, 65
Gordon, C. G., 40
Gorky, Maxim, 114
Grant, James, 10

Harlem, 52, 54–55, 82–83
Harmon Foundation, 50
Harrington, Ollie, 48
Hershey Chocolate, 46
Hoffman, Jerry, 64
Holiday, Billie, 48
Holte, Clarence, 54
Hornsby, George, 97–102
House of Children's Books (Moscow), 121–22
Hughes, Langston, 48, 119–23, 130–32, 171
Human rights, 195–96
Hunt, Richard, 50
Hutson, Jean, 54

I Wonder As I Wander (Hughes), 119, 130

India, 15, 161
Indians
 in Uganda, 10, 15–18, 21
Indians, American, 195
Industrialization, 12
Islam, 3, 4, 38–39, 61, 90, 137, 142,
 155, 161, 174

Jackson, Moses, 170–71
Jet magazine, 119
Jimma, Ethiopia, 72
Johnson, Hewlett, 126, 127, 128, 130
Jones, LeRoi, 48

Kabale, Uganda, 27
Kampala, Uganda, 10, 12, 13–14, 15,
 18, 21, 33, 90
Kanyoma, Odomaros, 27–28, 30
Kawawa, Rashidi, 88
Kayumov, Laziz, 150
Kenya, 1, 90
Key, Francis Scott, 78
Khamdamov (poet), 189, 191
Khartoum, Sudan, 1, 35, 37, 38, 40,
 42–55, 56
Khiva, 4, 136, 137
Kilimanjaro, Mount, 1, 87
Killens, John O., 48
King, B. B., 48
King, Martin Luther, 23, 192
Kitchener, Horatio Herbert, 40, 55
Kokand, 136, 183
Kotkin, Valentin, 114–15, 122
Krumskaya (sculptor), 150

Lawrence, Jacob, 48
League of Nations, 88
Lenin, V. I., 155, 176, 180
Lenin Museum (Tashkent), 155
Leopold II, King (Belgium), 3
Liberia, 45–46

Lugard, Frederick, 10, 12
Lurie, Frieda, 110, 114, 118, 121
Lyon, Ernest, 81

McKay, Claude, 48
Makale, Ethiopia, 57, 62
Malcolm X., 150
Margilan Silk Mill (Uzbekistan), 185,
 187–89, 192
Marriages, interracial, 133
Marshall, Paule, 48
Masaka, Uganda, 24–26
Mason, Morris, 97
M'Bow, Gana, 82
Mbarara, Uganda, 26
Menelik II, King (Ethiopia), 61, 68
Meschrabpom Films (Moscow), 131
Michaux, Louis, 54
Minaret Kalyan (Bukhara), 176, 178
Mingus, Charley, 48
Mombasa, Kenya, 15
Mora, Betty Catlett, 50
Moscow, 108, 110, 112–23, 141
Mudawie, Mohammed Y., 52, 54–55
"Muhammed Ali," 158, 167
Murphy, Carl, 134
Mussolini, Benito, 61

Nakolukin, Alexander, 110
Nasrulla, Emir, 174
Navoii, Alisher, 150
Nazareth, Ethiopia, 60, 74
Nikolaev, Alexander M., 114
Nkrumah, Kwame, 46
Nsubuga, Sam, 24
Nyerere, Julius K., 88–89, 90, 102

O'Dell, Jacks, 105, 113, 115, 141, 151,
 152, 159, 167
Olduvai Gorge, 87

Omar, Ahmed, 37–38, 42–43, 45, 51
Omdurman, Sudan, 1, 39, 55

Pan-Africanism, 46
Parker, Charley, 82
Parks, Rosa, 192
Peace Corps, 60, 62, 64, 65, 76
Pilinik, Nina, 121
Piskunov, Konstantin, 121
Prebitkevitch, Nadia, 110, 112, 113–14, 121, 141, 142
Pushkin, 133

Racism, American, 6, 38, 50, 67, 72, 73, 77–78, 85, 92, 93, 103, 171
Rawls, Lou, 48
Rechev, Eugene, 121
Republic Steel, 46
Robeson, Paul, 128–30, 150
Roosevelt, Eleanor, 125
Roosevelt, Franklin Delano, 125, 127
Russia, see Union of Soviet Socialist Republics

Salahi, Ibrahim el, 50, 56, 83
Samani, Ismail, 180
Samanid family, 174
Samarkand, Uzbekistan, 135, 136, 157–67, 172, 174
Sarts, 3
Schuyler, George S., 54
Scriven, Isaac, 169–70, 171
Selassie, Haile, 61, 70, 71, 72, 80, 85
Shifta, 1, 65
Shriver, Sargent, 64
Siberia, 126
Sinnette, Calvin, 54
Smith, Glenn, 72
Smith, Hedrick, 172
Solaro, Banjo, 81–82
Somalis, 60, 75

Soviet Central Asia, 3, 5, 105–23
 See also Bukhara; Ferghana; Samarkand; Tashkent; Uzbekistan
Soviet Power, The (Johnson), 126, 127
Soviet Union, see Union of Soviet Socialist Republics
Speke, John Hanning, 10, 88
State Department, U. S., Educational and Cultural Division, 5
Stieffelman, Oleg, 151–53
Sudan, 4
Sudan, Northern, 1, 35–56
 history, 38–41
 independence, 41
 nationalism in, 40
 population, 41
 women in, 43, 45
Sudan, Southern, 43, 45, 51, 52
Sutton, Bessie, 132
Sutton, John, 132–34, 167
Sutton, Percy, 132
Swahili, 89, 90, 94, 97, 102
Syracuse University, 126

Tamara, 176
Tamerlane, 134, 135, 136
Tanga, Tanzania, 97
Tanganyika, 4
Tanganyika, see Tanzania
Tanzania, 1, 87–103
 history, 87–88
 population, 90
 women of, 94, 102
Tashkent Museum of Literature, 150
Tashkent Union of Writers, 146, 150, 151, 152
Tashkent, Uzbekistan, 4, 108, 132, 136, 141–55, 167, 184
Theodore II, Emperor (Ethiopia), 61
Tigre Province (Ethiopia), 57, 64

Tigreans, 60
Timur, 160–61, 163

Uganda, 1, 4, 9–33, 97, 195
 history of, 10–11
 independence, 10, 21
 origin of name, 12
 people of, 9–10
 population, 9
Ukuno, 82
Ulugbek, King, 151–64, 166, 180
Union of Soviet Socialist Republics,
 3, 6, 105–93
Union of Soviet Writers, 7, 110, 113,
 114–15, 117
United Nations, 81, 82, 88
United States
 attitude of Ethiopians toward, 72
 racism in, 6, 38, 50, 67, 72, 73, 77–
 78, 85, 92, 93, 103, 171
United States Information Service, 5,
 30, 37, 71, 72, 85, 119
USSR
 Fax's invitation to the, 6–7
 population, 126
 women in, 114, 145
Uzbek, 3
Uzbek Committee for Relations with
 Writers of Asia and Africa, 141

Uzbek Exhibition of Economic
 Achievements, 145
Uzbek Writers' Union, 150
Uzbekistan, 3, 4, 5, 122, 125–93, 195–
 96
 history, 134–39
 See also Bukhara; Ferghana; Sam-
 arkand; Tashkent
 women in, 129, 137, 142, 145, 155,
 159, 178
Uzbeks, 3, 4, 132, 133, 134, 136–37,
 142, 144, 155, 167, 174, 180, 188,
 189, 191, 192, 195, 196

Victoria, Lake, 1, 9, 10, 13

Walker, Margaret, 48
Ward, Haskell, 60
White, Charles, 48
Wilson, John, 48
Wonji Sugar Estate (Ethiopia), 75
Works Progress Administration, 125,
 126, 127
Wright, Richard, 48
Wright, Sara, 48
Wyatt, Donald, 52

Zauditu Empress (Ethiopia), 61